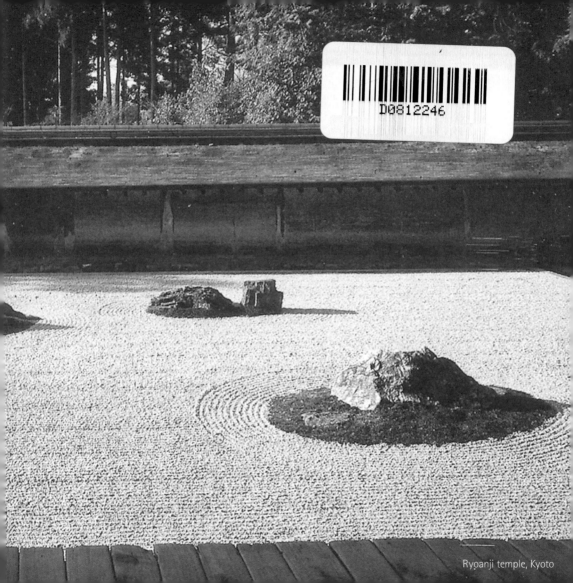

Ryoanji temple, Kyoto

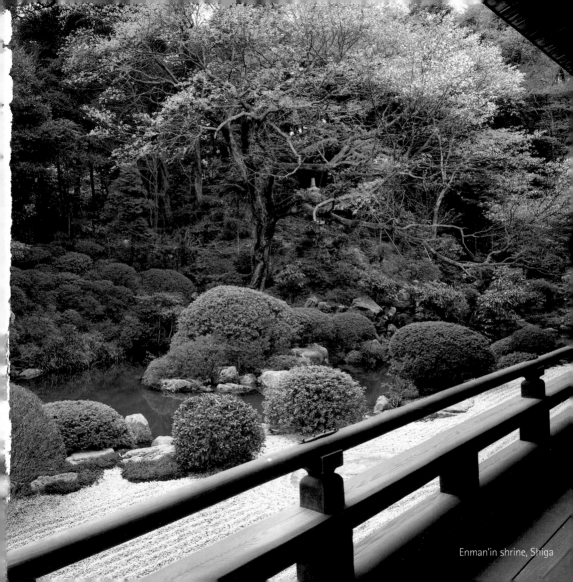

Enman'in shrine, Shiga

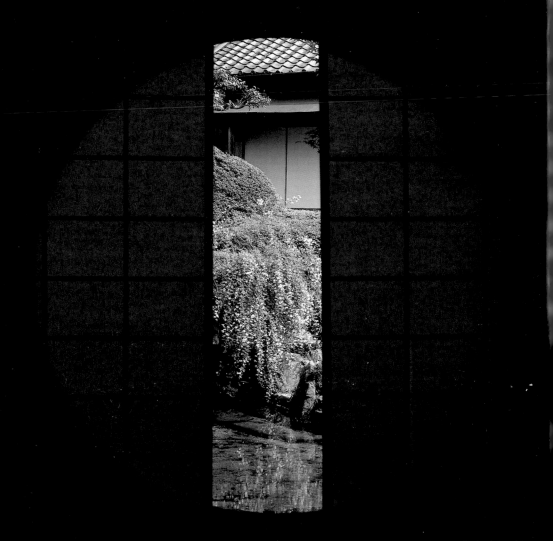

Jizoin shrine, Mie

無限の空間

Infinite Spaces

The Art and Wisdom of the Japanese Garden

Edited by Joe Earle
Introduction by Julie Moir Messervy
Photographs by Sadao Hibi

TUTTLE Publishing

Tokyo | Rutland, Vermont | Singapore

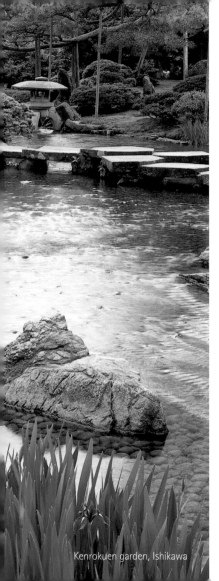

Kenrokuen garden, Ishikawa

This new edition first published in 2013 by Tuttle Publishing, an imprint of Periplus Editions (HK) Ltd.

www.tuttlepublishing.com

English language translation of *Sakuteiki* and introductory note copyright © 2000 by Joe Earle

Photographs copyright © 2000 by Sadao Hibi

Introduction copyright © 2000 by Julie Moir Messervy

Library of Congress Cataloging-in-Publication Data in process

ISBN 978-4-8053-1269-8

Distributed by
North America
Tuttle Publishing
364 Innovation Drive, North Clarendon, VT 05759-9436 U.S.A.
Tel: 1 (802) 773-8930; Fax: 1 (802) 773-6993
info@tuttlepublishing.com / www.tuttlepublishing.com

Japan
Tuttle Publishing
Yaekari Building, 3rd Floor, 5-4-12 Osaki, Shinagawa-ku, Tokyo 141 0032
Tel: (81) 3 5437-0171; Fax: (81) 3 5437-0755
sales@tuttle.co.jp / www.tuttle.co.jp

Asia Pacific
Berkeley Books Pte. Ltd.
61 Tai Seng Avenue #02-12, Singapore 534167
Tel: (65) 6280-1330; Fax: (65) 6280-6290
inquiries@periplus.com.sg / www.periplus.com

15 14 13 10 9 8 7 6 5 4 3 2 1
Printed in Malaysia 1301TW

TUTTLE PUBLISHING® is a registered trademark of Tuttle Publishing, a division of Periplus Editions (HK) Ltd.

Contents

 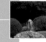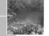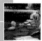

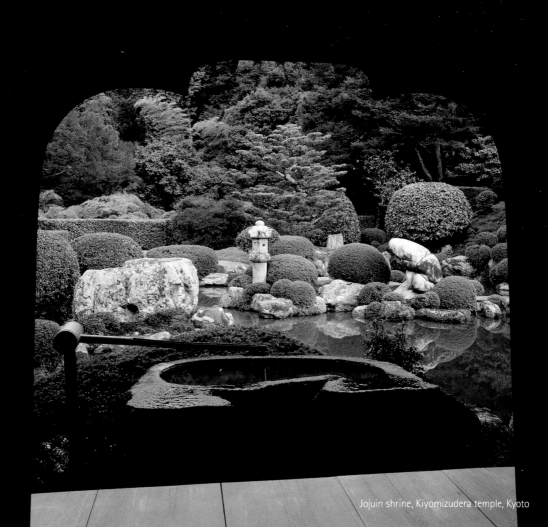

Jojuin shrine, Kiyomizudera temple, Kyoto

Introduction

Julie Moir Messervy

With the publication of this beautiful book, one of the earliest treasures of Japanese garden design is at last available to the Western gardener. *Infinite Spaces* combines two remarkable elements: the secret teachings preserved in Tachibana no Toshitsuna's *Sakuteiki* (Notes on Garden Design) as translated by Joe Earle and the visual artistry of the gardens themselves as photographed by Sadao Hibi. *Infinite Spaces* offers us all a chance to partake of the art and wisdom of *Sakuteiki*. Let us look at the history of Japanese garden design to understand how the ideas set out in this ancient text have continued to exert their influence throughout the ages.

Religion and Garden Design

According to Japan's indigenous religion, Shinto, certain natural objects—mountains, hills, trees and stones—house divine spirits. Even today, a hiker in the forest might come upon a shrine area spread with white gravel and enclosed in simple bamboo or rope fencing. Each vacant shrine site, standing in the pristine forest, suggests the belief in the sanctity of natural beauty that is at the heart of Japanese garden design.

During the Nara period (710–794), there was extensive cultural intercourse between Japan and Tang-dynasty China. In its gardens, architecture, legal systems, city design, and even language, the island nation began to borrow from its more sophisticated continental neighbor.

Stroll Gardens

Residential gardens of the Heian period (794–1185) were bright and relaxed spaces, featuring large ponds with islands for boating or viewing. Aristocrats such as Tachibana no Toshitsuna, the presumed author of *Sakuteiki*, occupied south-facing shinden-style mansions and employed shoji (rice-paper screens) and tatami (grass mats that covered the floor). Pure Land Buddhism, which offered the hope of salvation and entrance into the Western Paradise after death, exerted a religious influence on garden design.

Some of the concepts introduced in *Sakuteiki* can be seen in the famous "Moss Temple," Saihoji, in the western hills of Kyoto. Said to have been created by the great Buddhist prelate Muso Kokushi (1275–1351), the garden was originally built in the earlier Pure Land lake-and-islands pattern, but was infused with a new religious spirit, that of Zen Buddhism, in 1339. Earlier gardens were designed to be seen from the interior of a building or from a boat on a pond, but at Saihoji the lower part of the four-and-a-half acre site is designed as a stroll garden, in which views of the landscape change as one walks through its spaces along tamped earth paths.

Meditation Gardens

During the Muromachi period (1335–1573), small Zen gardens were built in which Zen monks tried many different approaches to the design of stone gardens in an attempt to convey the Zen concepts of discipline, self-examination, and ultimate enlightenment. Often placed on the south-facing side of a Zen temple's prayer hall, *karesansui* meditation gardens featured white sand or gravel

as the ground cover, raked in various patterns to suggest waves, droplets, ripples, or other effects. The garden of Dalsen'in in Kyoto houses a miniature natural landscape, said to be a three dimensional representation of the Chinese scroll paintings that influenced Zen thought at the time. Three sections of the garden, two of them less than ten feet in depth, hold stones arranged as a course of water falling over a waterfall, flowing through a mountain streambed, past a broad river and into a vast ocean, all indicated through stones and raked gravel.

Other gardens are more abstract. The most famous of these is Ryoanji, a rectangular space about the size of a tennis court with five "islands" of moss and stone, comprising five, two, three, two, and three rocks respectively, rising from a bed of raked gravel symbolizing the sea. While the composition as a whole is asymmetrical, balance is achieved through hierarchy. One's eyes and mind travel around the garden in a kind of circle, from the highest rocks to the lowest, giving the garden a sense of motion. Soothed by the serene simplicity of the spare materials, one becomes an island, like Japan itself, floating upon a vast sea.

Tea Gardens

The area that surrounds a tea house is called *roji*, literally "dewy path" or tea garden. Its purpose is to spiritually prepare visitors by leading them on a journey of stepping-stones, over thresholds, through gates and past lanterns, to a water basin where they purify hands and mouth before moving on to the tea house where the host serves powdered green tea in a ritualized ceremony.

Since a tea garden is designed to provide a series of spatial impressions in a tiny area, the design of its path is critical. *Tobiishi* (stepping-stones) are a constant motif, variously used. Small *tobiishi* placed next to each other slow the pace and direct the gaze downward, larger stones enable the guest to stop to look at some special view, and *nobedan* (long stone planks) allow the step to quicken in anticipation of the tea house around the bend. Each stone has a purpose, whether it be to focus the visitor upon the act of moving through the garden, to rid the mind of mundane thoughts, or to anticipate the quiet serenity of the tea ceremony.

Current Trends in Japanese Gardening

Modern Japanese gardens often combine the three major styles—the stroll garden, the meditation garden and the tea garden—and Western and Chinese features are increasingly being incorporated into Japanese design in the form of public and semi-public parks, institutional gardens, and private residences. Despite its great antiquity, *Sakuteiki* remains a vital influence for garden-making in today's Japan. Enjoy Tachibana no Toshitsuna's words, delight in these exquisite photographs, and learn the secrets of Japanese garden design as you absorb the art and wisdom contained in *Infinite Spaces*.

A Note on *Sakuteiki*

Joe Earle

We know very little about the origins of *Sakuteiki (Notes on Garden Design)* beyond the fact that it was already in existence by the year 1289, when a calligrapher called Kujo Yoshitsune inscribed his name at the end of the oldest surviving copy of the work. Most Japanese scholars agree, however, that *Sakuteiki* was written about a century earlier by Tachibana no Toshitsuna (1028–94), also known as Fujiwara no Toshitsuna.

Toshitsuna's presumed father Yorimichi was the head of the Fujiwara family of Regents, and it was Yorimichi's father Michinaga (966–1027) who had brought the power of that great clan to its peak by marrying his daughters into the Japanese Imperial family: towards the end of his life Michinaga could boast that three Emperors were his sons-in-law and four were his grandsons. By the time that *Sakuteiki* was written, however, a decline had set in, not only in the prestige of the Fujiwara but also in the power and even the relevance of the entire system of government they headed.

The same feeling of nostalgia that pervades Japan's greatest novel, *Genji monogatari (The Tale of Genji)* completed by Lady Murasaki Shikibu not long before Toshitsuna's birth, is expressed by the author of *Sakuteiki* when he laments characteristically that "These days there is no one left who really understands gardening." *Sakuteiki* tells us that when Toshitsuna's father Yorimichi wanted to restore the Kayanoin palace, it was already impossible to find artisans who were skilled in building gardens, so that in the end Yorimichi himself was forced to oversee the work. It was then, perhaps, that Toshitsuna gained his early experience of garden art.

Sakuteiki is best understood as an attempt to preserve the accumulated practical experience of centuries of garden design, illuminated by the author's elite knowledge of Chinese and Japanese literature and belief. The original text runs to over 12,000 characters and this is no more than a partial rendering in a contemporary idiom intended to appeal to gardeners rather than historians. It should also be pointed out that Toshitsuna regarded gardening as mainly a matter of landscaping. He has very little to say about plants (other than trees) and since the few remarks he does make apply to very specific design situations these too have been omitted.

Sakuteiki starts off with an exposition of general principles and continues with practical advice on different features, but thereafter it jumps bewilderingly from subject to subject, with a mixture of detailed categorizations, historical anecdotes, and lists of taboos and prohibitions. For this reason it was decided to rearrange the text under headings that would appeal to modern gardeners and complement Sadao Hibi's superb photographs. The extraordinary thing is that so much of this nine-hundred-year-old text fits perfectly with images of later Japanese gardens and is also in tune with garden design as it is practiced around the world today. The belief in our capacity to improve on nature at the same time as respecting its innate qualities, the insistence on adhering to general principles rather than detailed rules, even the interest in the complex of Chinese beliefs and auspicious practices that we now call *Feng Shui*—all these aspects of *Sakuteiki* continue to strike a chord in the twenty-first century.

Above all we should heed Toshitsuna's advice on the importance of "secret teaching," meaning (I suspect) the kind of teaching that cannot be set down in words but can only be learned through experience. The best way to use *Sakuteiki* is to get out into your garden and put its ideas into practice.

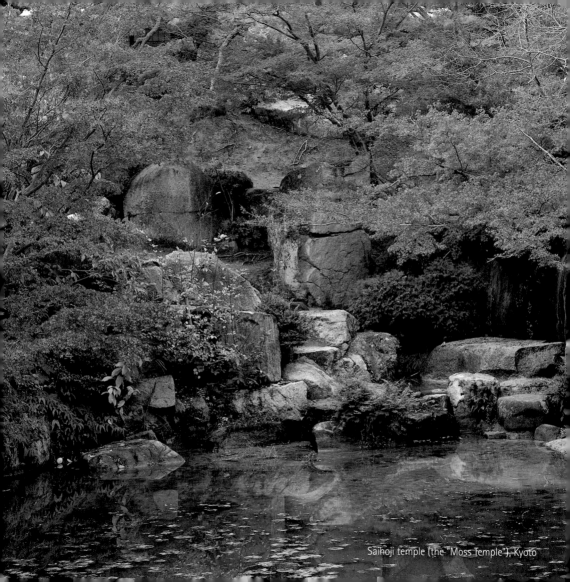
Saihoji temple (the "Moss Temple"), Kyoto

作庭記

Shimotokikuni family garden, Ishikawa

Chapter 1

Principles of Garden Design

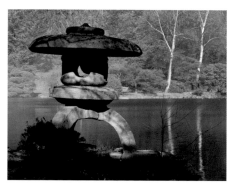

Oyakuen, Iwate

"Always remember
to make the style
suit the site."

"These days there is no one left who really understands
gardening. They just look at natural landscapes and
then go ahead with their design without observing the
many important taboos that have to be observed."

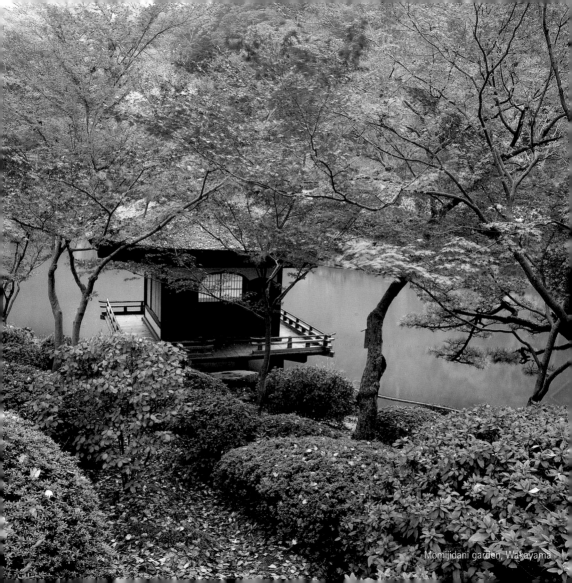
Momijidani garden, Wakayama

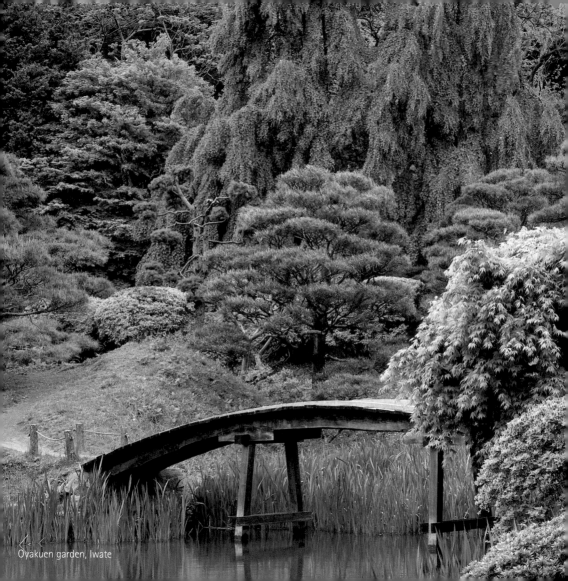
Oyakuen garden, Iwate

"We should always remember that it is not practical for ordinary people to live in the depths of the mountains. So how can it be wrong for them to build waterfalls by their hillside cottages and plant a few trees as well? Pay no attention to anyone who tells you that you must not plant trees in this or that place!"

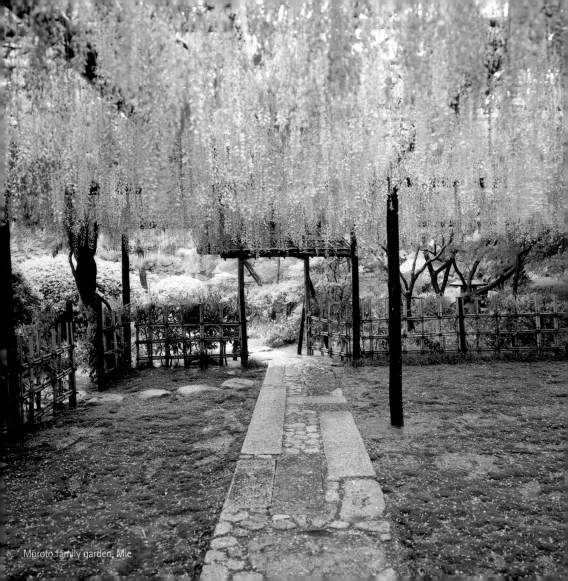

Moroto family garden, Mie

"It has been said that stones arranged by man can never be better than a natural landscape. But in my extensive travels around the country I can remember several occasions when I have been struck by the beauty of a particular spot, only to find that the adjoining scenery is quite unremarkable."

"Take your inspiration from the master-pieces of the great designers of the past, but keep your client's wishes in mind and make sure that the garden is also an expression of your own personal vision."

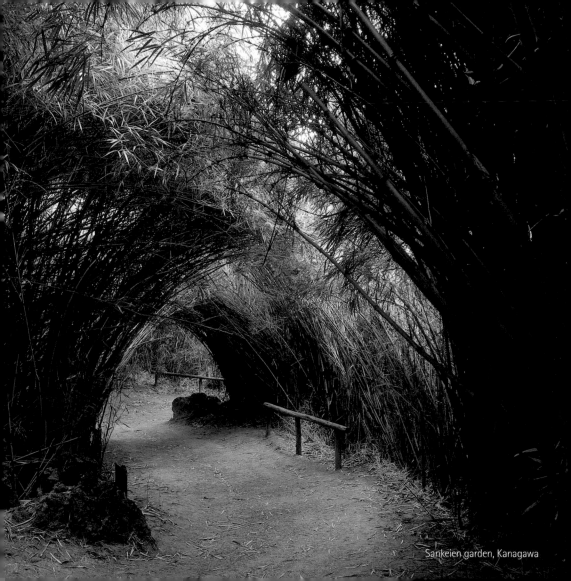

Sankeien garden, Kanagawa

"Think of the finest natural landscapes you have seen, select those that you find most inspiring and adapt them to your plan, copying their overall features and making them blend in with your chosen site."

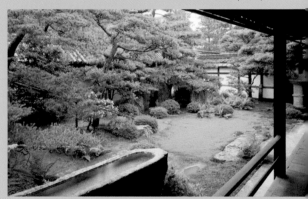

Tokaian sub-temple, Kyoto

名所

"The painter and gardener Hirotaka taught that stones should never be placed carelessly."

Kyugetsutei pavilion, Shiga

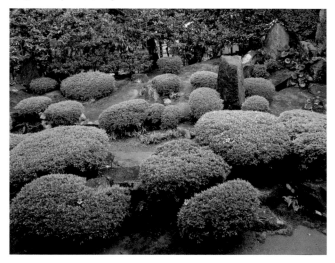

"Because it is difficult to appreciate an arrangement at close quarters you should always try to make sure that your design will look best when viewed at a short distance."

"When you design your garden you can pick and choose from the very best that you have seen in nature, ensuring that every stone contributes something to the overall effect."

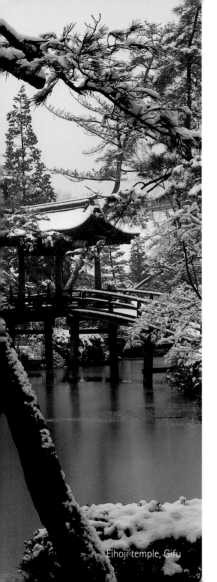

Eihoji temple, Gifu

"It is sometimes said that landscape designs and arrangements of stones carry deeper, hidden, meanings. For example, the earth can symbolize the ruler and the water his subjects. Water can only go where the earth allows it and must come to a halt where the earth obstructs it.

According to one theory, the mound symbolizes the ruler, the earth his subjects and the water his ministers. In this analogy the water flows where the mound dictates, but if the mound is unstable it will be washed away by the water, symbolizing a weak ruler being deposed by his subjects. If the mound is unstable it is because there are no stones supporting it, and if a ruler is weak it is because he has no ministers. A mound is made complete by stones just as a ruler is protected by his ministers. This goes to show what an important contribution stones can make to a successful landscape design."

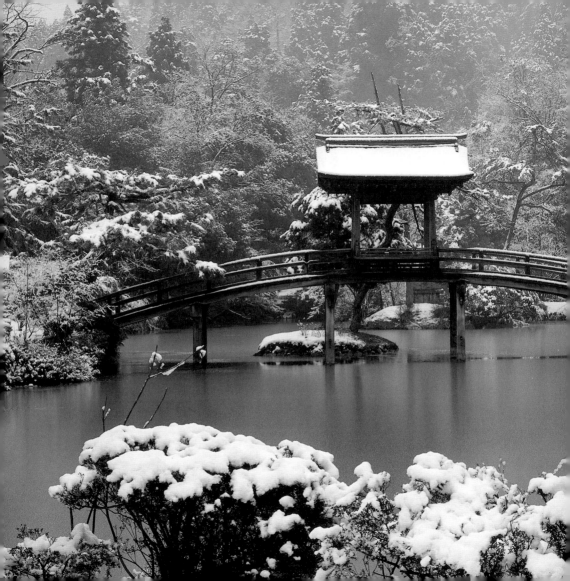

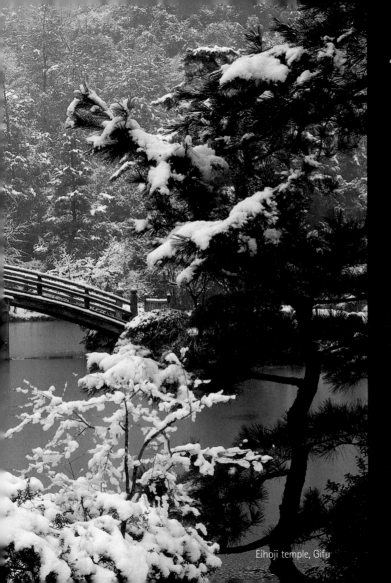

"Make sure that your design harmonizes with the lie of the land, the shape of the pond and any other existing features. As you set out your garden, never forget how the site looked in its natural state."

風情

Eihoji temple, Gifu

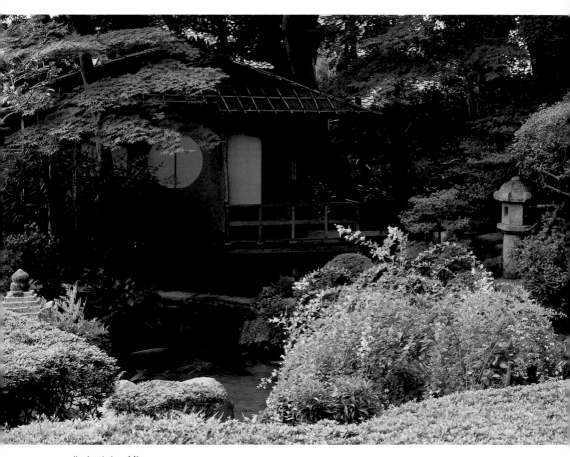

Jizoin shrine, Mie

"When you are making up your mind how many stones to use and where to place them, be guided by the lie of the land as well as your own passing mood."

Koetsuji temple, Kyoto

"It makes me laugh when ignorant visitors insist on being told the specific 'style' of every garden they see!"

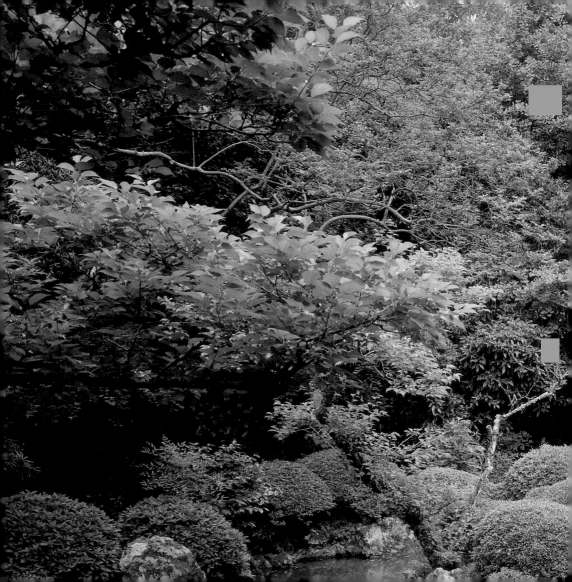

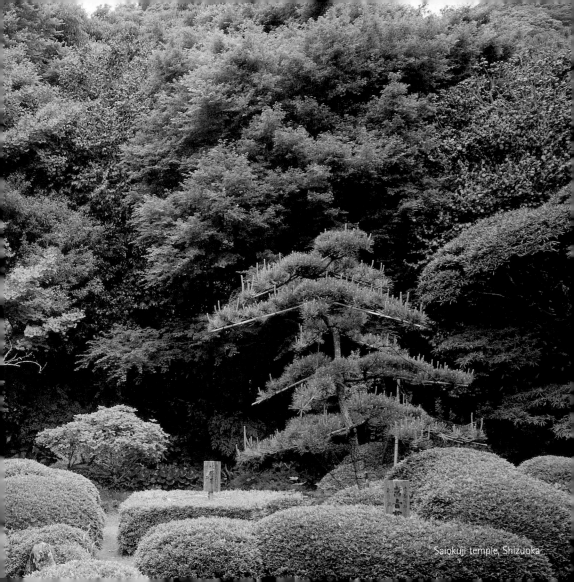
Saiokuji temple, Shizuoka

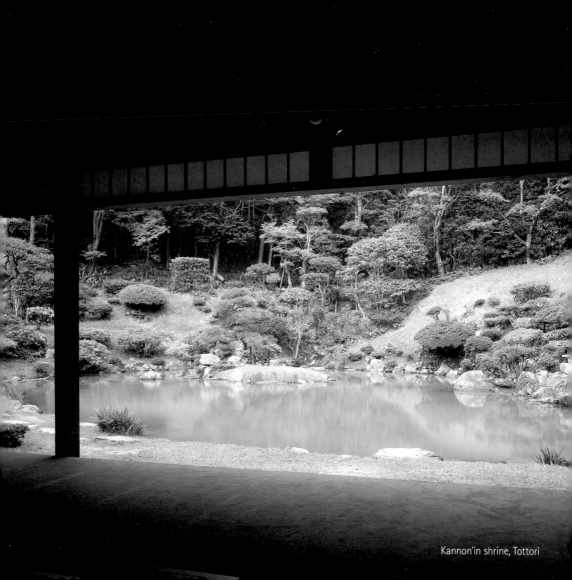

Kannon'in shrine, Tottori

Former Yasuda family garden, Tokyo

Chapter 2

Pools and Lakes

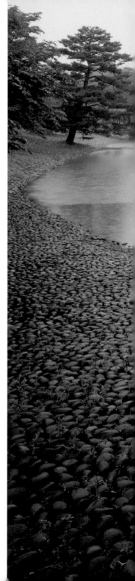

"Ponds should always be shallow.
Deep ponds allow the fish to grow too
big and turn into poisonous bugs."

Enman'in shrine, Shiga

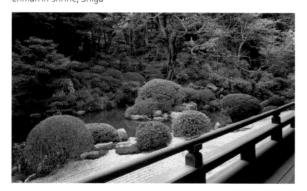

"When you plan to dig a pond and set
out your stones, first take a careful look at
the lie of the land. In shaping your pond,
building islands and deciding where
the water should flow in and out, work
in harmony with the environment."

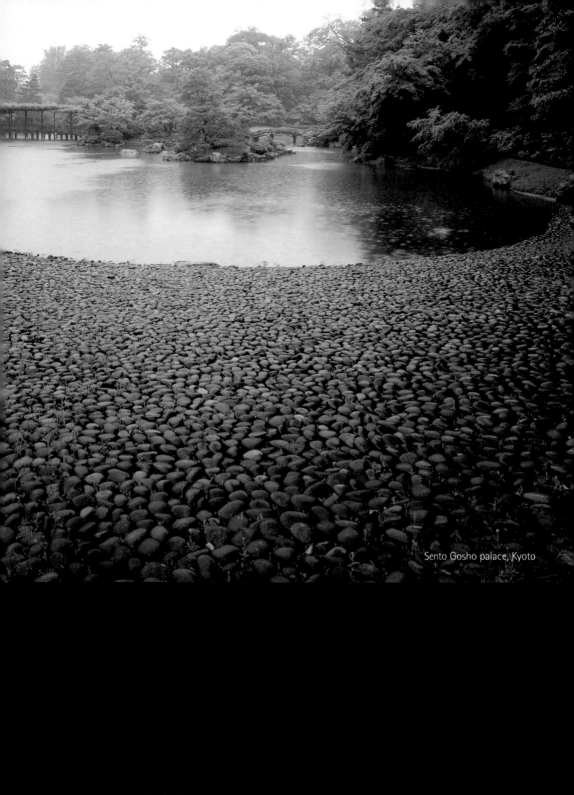
Sento Gosho palace, Kyoto

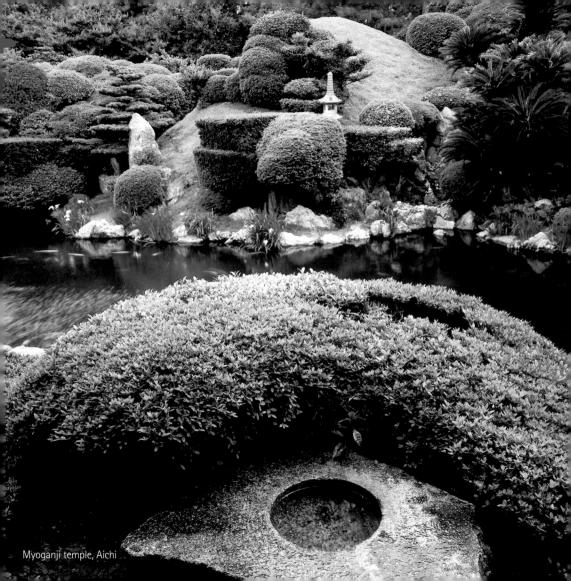

Myoganji temple, Aichi

"It should be impossible to see where the water goes in and out. Keep the inlets hidden, and ensure that the pond is filled to the brim."

"Water takes its shape from the container into which it flows, with both good and bad results. Therefore you should always exercise the greatest care with the design of your ponds."

"When you are designing the islands for your garden, be sure to take into account both the appearance of the surrounding land and the size of the pond."

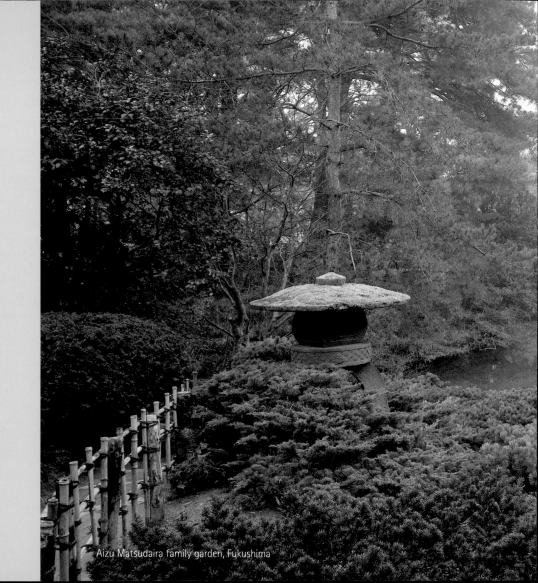
Aizu Matsudaira family garden, Fukushima

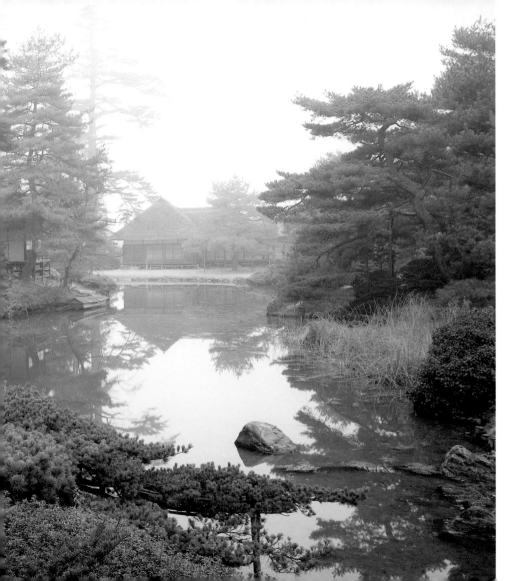

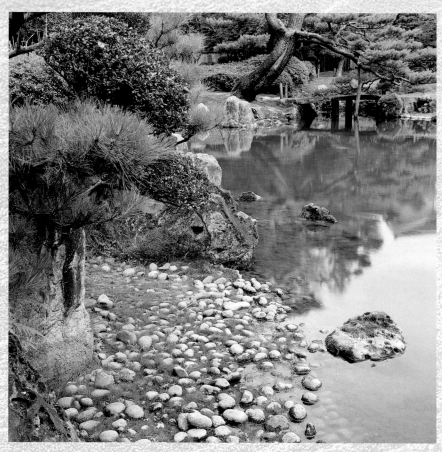

Sakai family garden, Yamagata

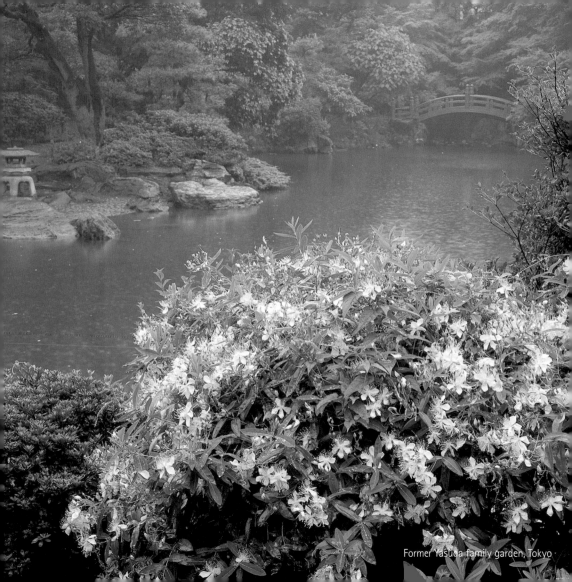

Former Yasuda family garden, Tokyo

"Your ponds and conduits should be laid out so that the water flows towards the southwest, helping to carry inauspicious influences from the direction of the Blue Dragon in the east to that of the White Tiger in the west."

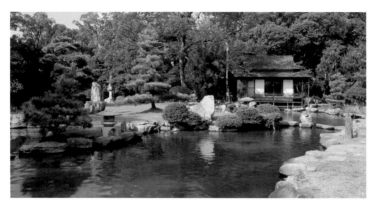

Tenshaen garden, Ehime

"If you have a large pond with islands in it, you should try to make the pond look like the sea, while the rest of the garden should be landscaped and planted to resemble a piece of calligraphy."

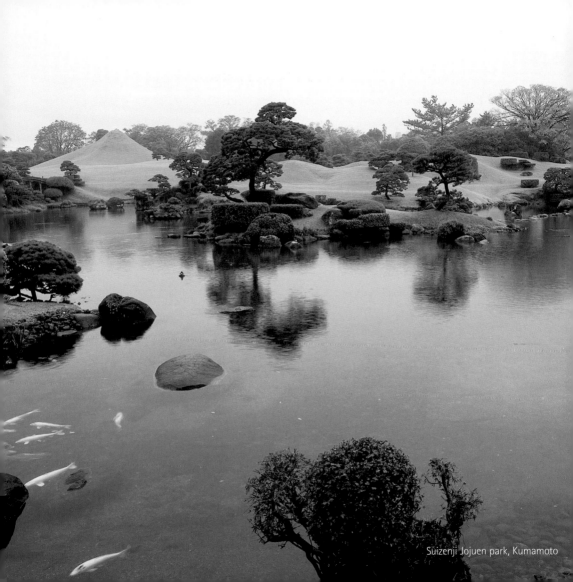

Suizenji Jojuen park, Kumamoto

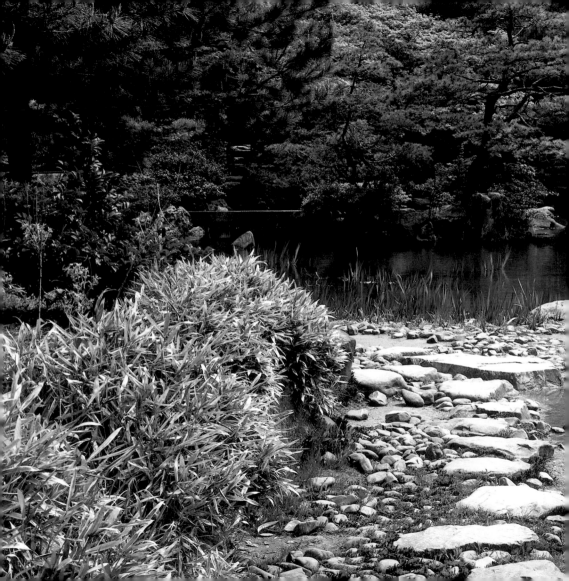

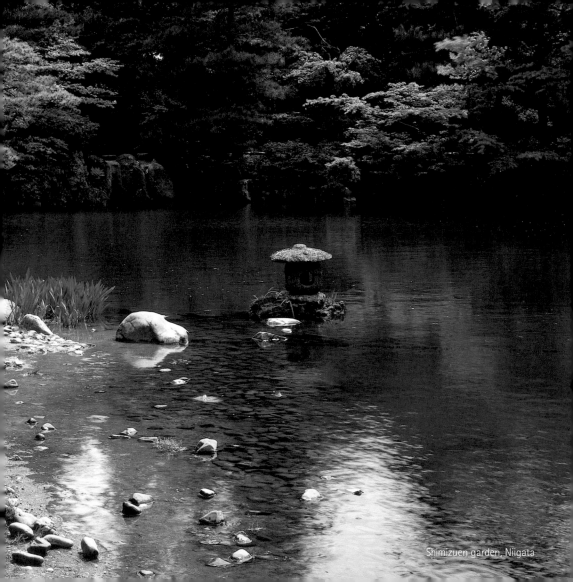

Shimizuen garden, Niigata

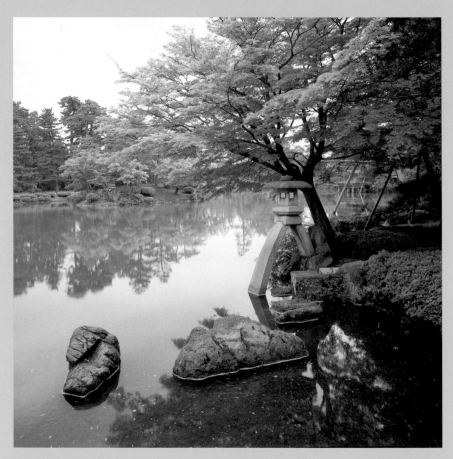

Kenrokuen garden, Ishikawa

"To create the effect of a wild seacoast, start by scattering a few rough, pointed rocks along the shore of your pond. Then place lines of rocks out into the water, so that they look as if they have just grown from the bottom of the pond. There should also be a few isolated rocks still further away from the shore."

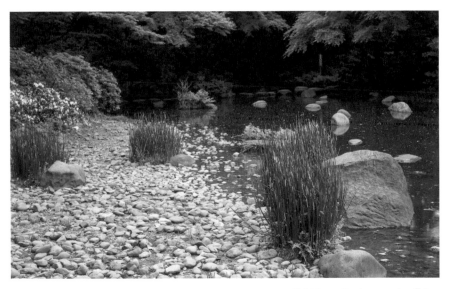

Koishikawa Korakuen garden, Tokyo

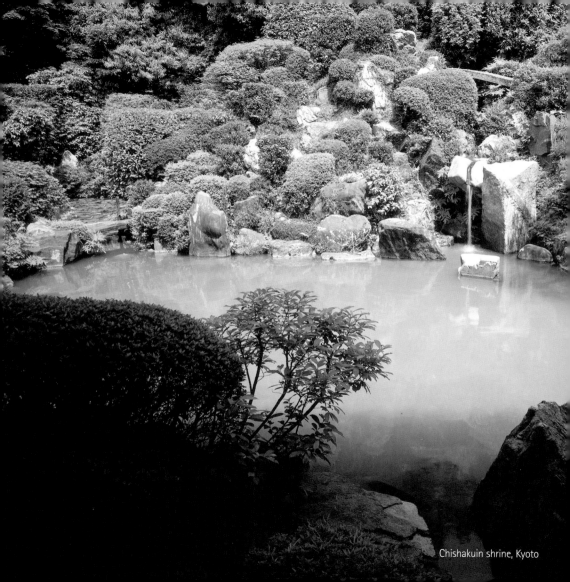
Chishakuin shrine, Kyoto

滝を立る事

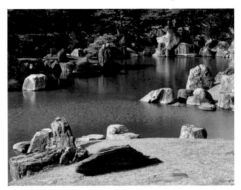

Chapter 3

Waterfalls

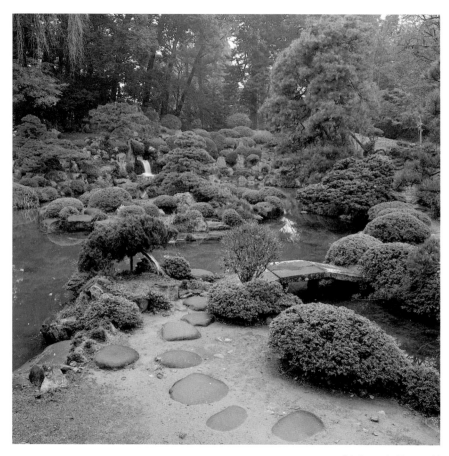

Erinji temple, Yamanashi

"Fudo, the Implacable Guardian King of Buddhism, once swore that waterfalls three feet high or more were symbols of his physical body, still more so if they were as much as ten or twenty feet in height. Waterfalls as tall as this always take the form of the Buddhist trinity of Fudo with two attendants, symbolized by two smaller stones standing at the foot of the main vertical stone. The holy scriptures state:

He who sees my body shall attain enlightenment. He who hears my words shall learn to reject evil and practice good... That is why they call me 'Implacable'...

Among the many forms taken by Fudo the Implacable, the waterfall most truly reveals his true nature."

"When laying out the area below the waterfall, start by placing two well-shaped stones at the left and right, each of them about half the height of the larger rocks framing the cascade, then place smaller stones downstream in a way that suits the mood of the first two stones.

For best results, make the area below the waterfall as wide as possible and place plenty of stones in the middle of the water so that the stream is divided in two. After that, you can lay out the stream just as you would for an ordinary water feature."

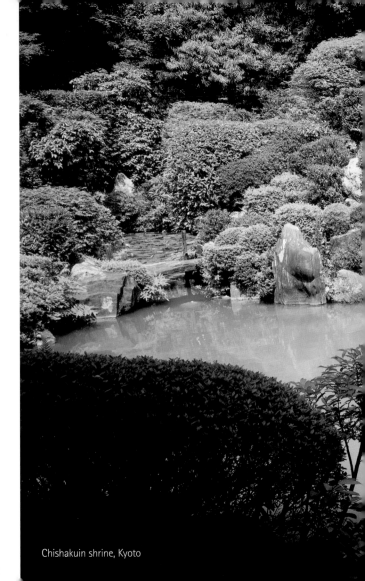

Chishakuin shrine, Kyoto

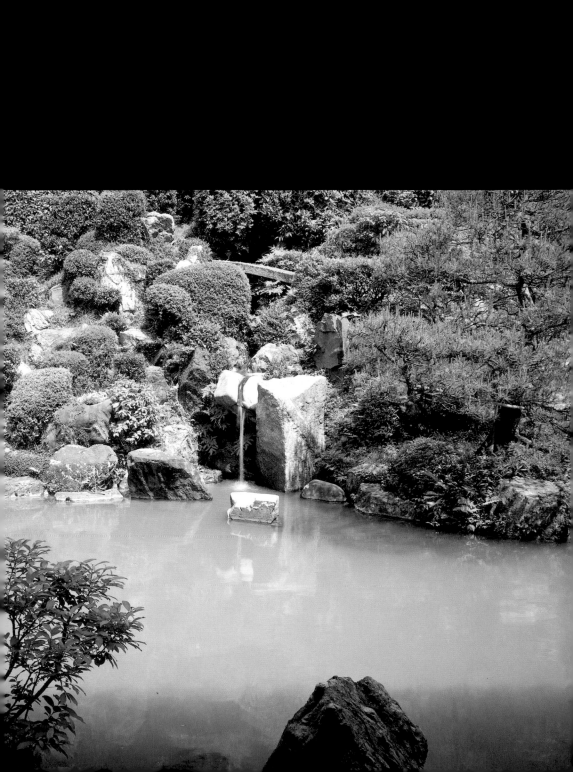

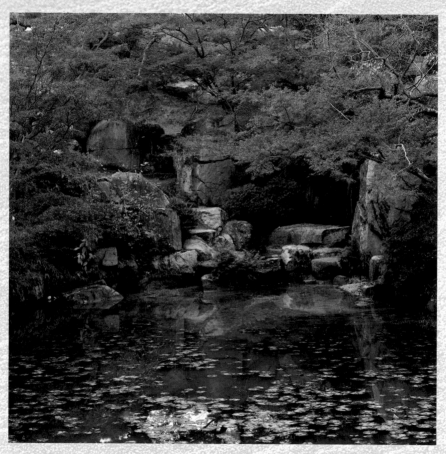

Mori family garden, Yamaguchi

"A stream can be made to descend a waterfall in several different ways. In the *Facing* style, there should be two elegantly shaped cascades falling side by side. In the *One-Sided* style the cascade falls down the left hand side of the vertical stone. In front and to the left of the vertical stone, place another stone about half its size, and shape this stone so that when the cascade falls onto it, the water whitens and drops to the right. In the *Following* style the water falls down along the cracks in the surface of the vertical stone. For the *Separated* style, on top of the vertical stone place another stone with a well-defined angle along one edge in such a way that it does not obstruct the flow of water. The water passes swiftly over the edge and falls down without actually touching the face of the vertical stone. In the *Corner* style the top of the waterfall is tilted to one side so that it is seen to good effect when viewed from the best room in your house.

To create a waterfall in the *Cloth* style you need to find a really well-formed vertical stone and then shape the stream above the cascade so that the water slows down and drops gently over the edge; the waterfall will then look like a piece of cloth that has been hung out to air. For the *Threads* style, on top of the vertical stone place another stone with a jagged, irregular edge which will divide the water into several little thread-like cascades. For the *Compound* style set up two vertical stones and without trying anything too elaborate just let the water fall down in two or three steps."

Nijo castle, Kyoto

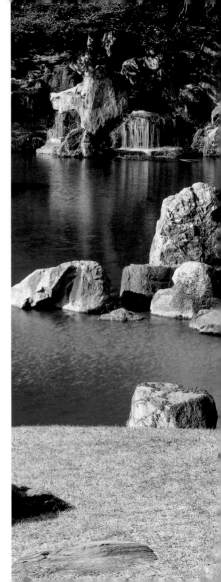

月に向ふべきなり

"It is sometimes said that
you should not build
waterfalls in places that
are dark and overhung by
trees. This advice can be
safely ignored. In fact
waterfalls that descend
from tree-darkened ravines
are particularly good to
look at, although all the
examples I have seen are
in old gardens."

"It is sometimes said that you
should try to manipulate your
waterfall so that the falling sheet
of water reflects the light of the
moon. I expect there is a secret
teaching about this, or you could
probably learn a lot from Chinese
gardening books!"

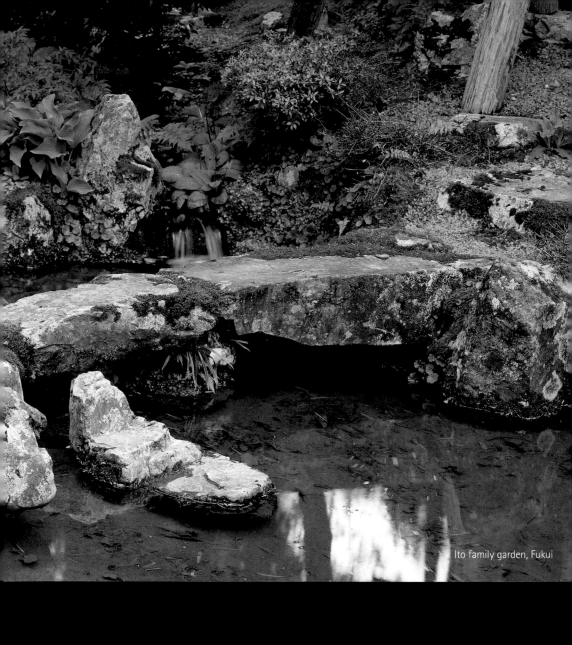

Ito family garden, Fukui

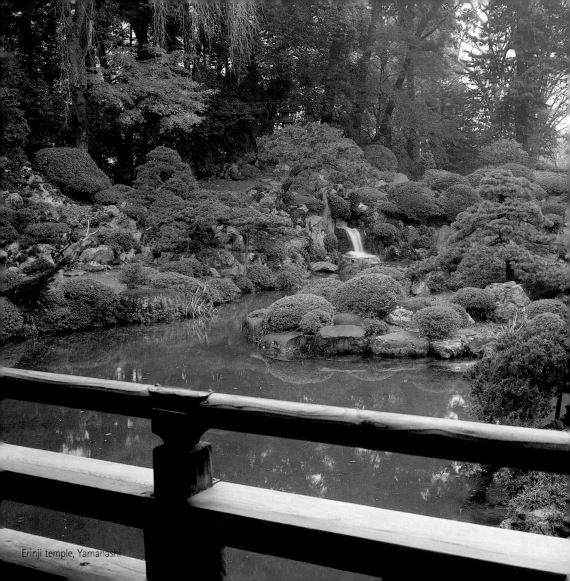
Erinji temple, Yamanashi

"If you look at natural waterfalls, you will notice that high waterfalls are not always wide, and low waterfalls are not always narrow. The only thing that makes any difference is the width of the lip over which the water actually flows. All the same, a waterfall three or four feet high should not be more than about two feet wide.

A low, wide waterfall is unsatisfactory in several respects. It can look very flat or even be mistaken for a dam, and if the point where the water falls over the rock is fully visible, the whole scene will lack depth."

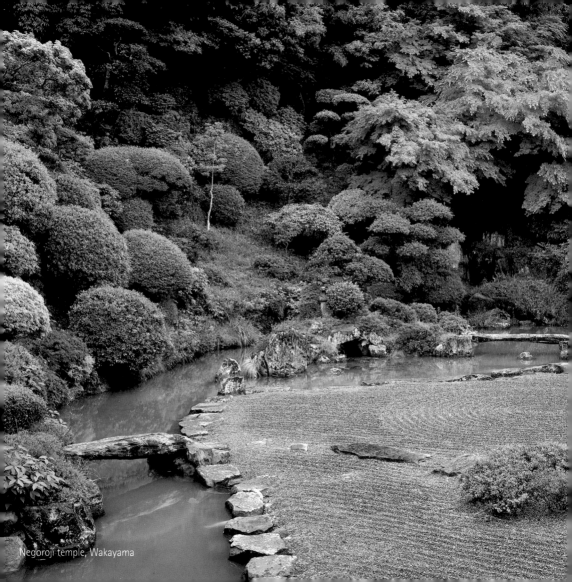

Negoroji temple, Wakayama

遣水の石を立る事

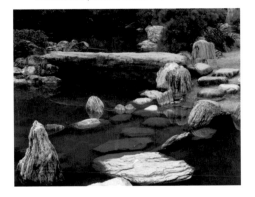

Senshukaku pavilion, Tokushima castle, Tokushima

Chapter 4

Streams

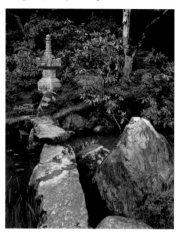

Kongorinji temple, Shiga

"When you place a lot of stones at a point where the stream makes a turn, they may seem just right if you are next to them but look surprisingly artificial when you view them from a few paces away."

"To create the effect of a river landscape, shape the stream like the meandering trail left by a dragon or snake. Decide where you want the stream to turn a corner, then choose a really well-shaped stone and place it there. Everything else you do in the garden should be dictated by this first stone. There is a secret teaching about this!"

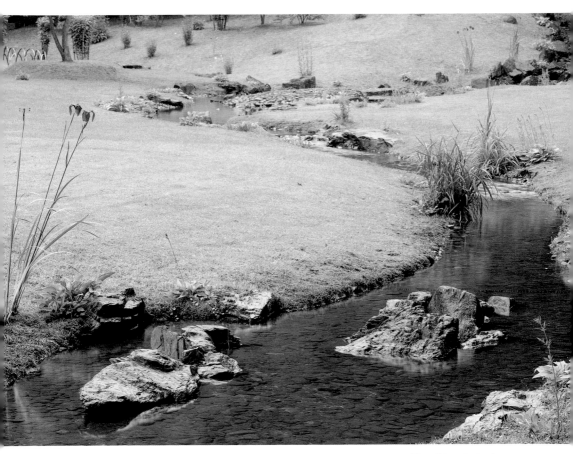

Motsuji temple, Iwate

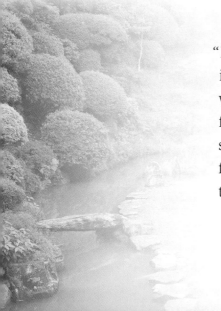

"When setting the gradient for your garden streams, the ratio of height to distance should be three in one hundred: this makes the water flow along smoothly with a gentle murmur. But in the lower reaches, where the landscape is gentler, the water will be pushed along by the faster water upstream."

"No matter where a stream flows from, it should be interesting to look at without necessarily being in the latest fashion. Dig the channel so that the stream flows this way and that, passing first one hillside and then another as the landscape dictates."

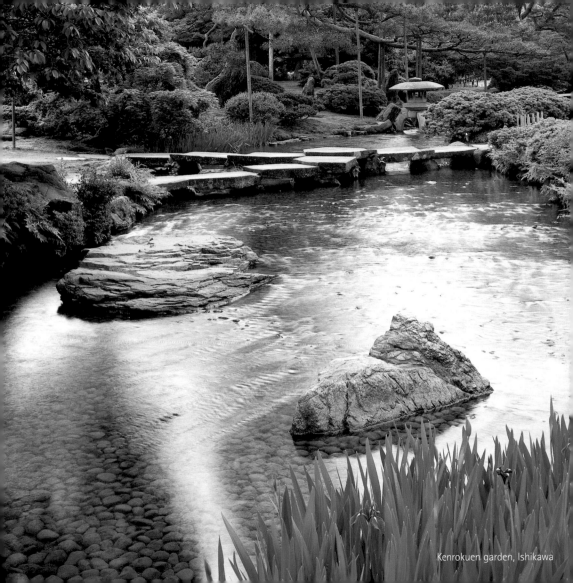

Kenrokuen garden, Ishikawa

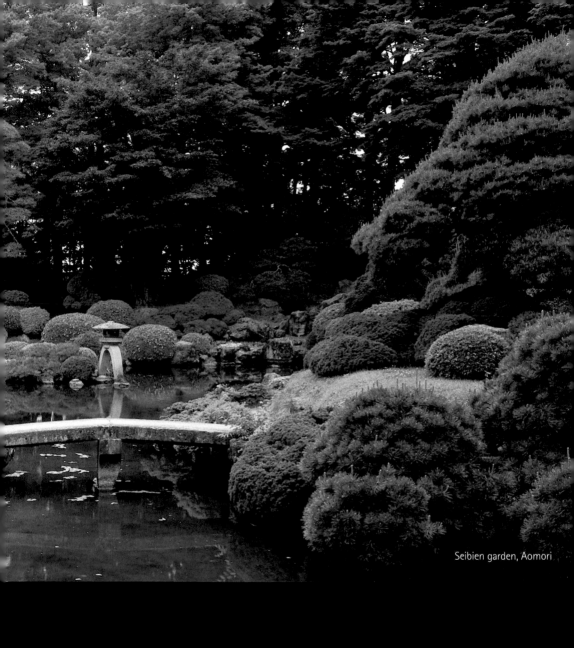

Seibien garden, Aomori

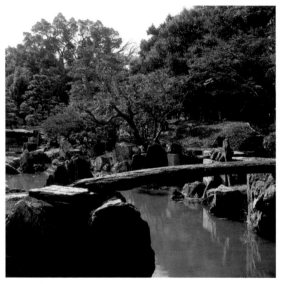

Nijo castle, Kyoto

"When laying out a stream, never pack stones tightly together in places where they will easily catch the viewer's attention. Instead, groups of stones should be positioned where the stream emerges from under your house, where it goes round the side of a mound, where it flows into the pond, or where it makes a sharp bend.

Start by putting one stone at each of these points and then add as many or as few other stones as the first stone dictates."

遣水

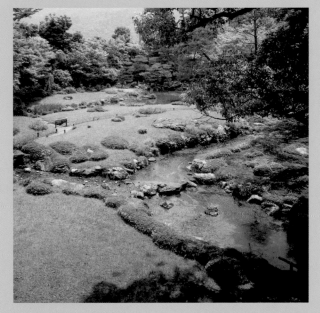

Murin'an sub-temple. Kyoto

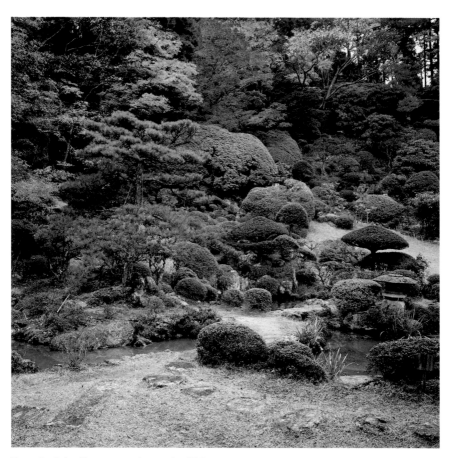

Fumon'in shrine, Koyasan temple complex, Wakayama

"When arranging the stones for a stream, start by concentrating on points where the stream makes a sharp bend. Make it look as though there was always a stone at each bend and the water was forced to turn a corner because it could not wash the stone away. After the stream has turned it will flow with extra momentum and strike hard against the next obstacle it encounters. Wherever it looks as though this is going to happen, install a 'turning-stone,' doing the same for each subsequent bend in the stream. Elsewhere, place stones here and there in the stream as you think fit, but make them look as if they had almost been left there by accident."

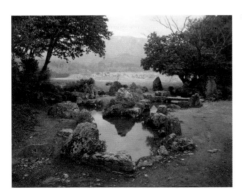

"Every home should have a spring. There is nowhere better to escape the summer heat."

The former Shurinji temple, Shiga

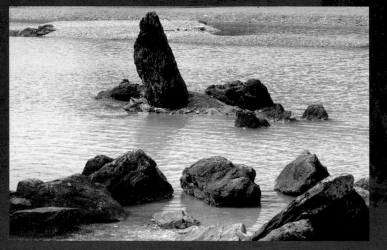

Motsuji temple, Iwate

大海様

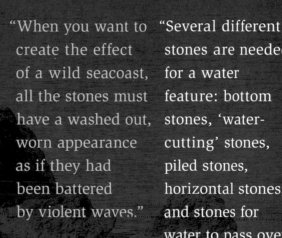

"When you want to create the effect of a wild seacoast, all the stones must have a washed out, worn appearance as if they had been battered by violent waves."

"Several different stones are needed for a water feature: bottom stones, 'water-cutting' stones, piled stones, horizontal stones, and stones for water to pass over. All of these should have their bases buried deep in the bed of the stream."

Saimyoji temple, Shiga

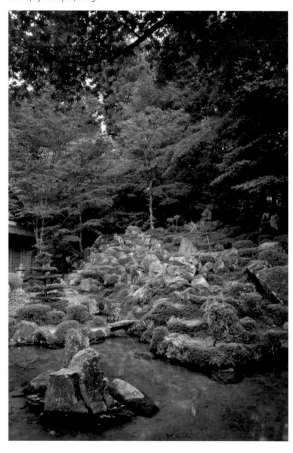

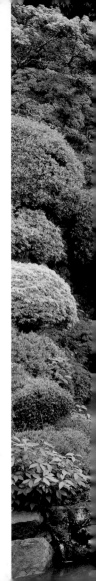

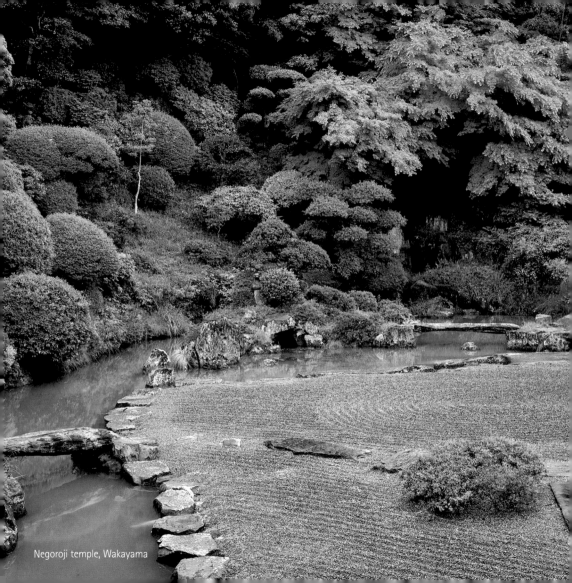
Negoroji temple, Wakayama

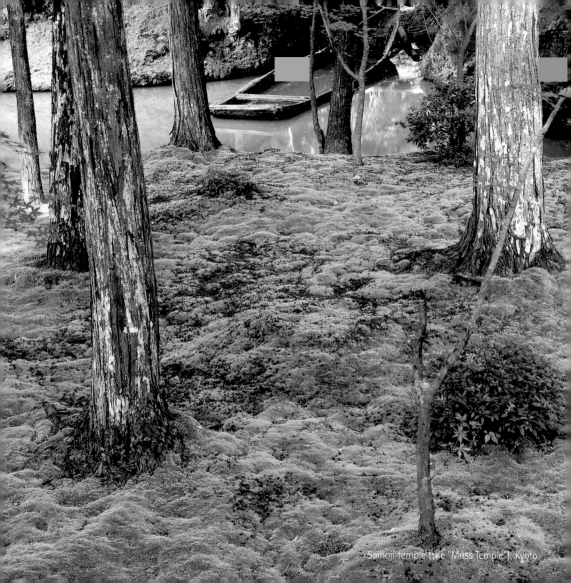

Saihoji temple (the "Moss Temple"), Kyoto

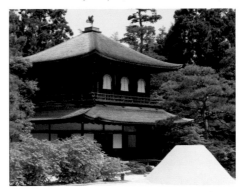

Jishoji temple (the "Silver Pavilion"), Kyoto

Chapter 5

Trees
and Mounds

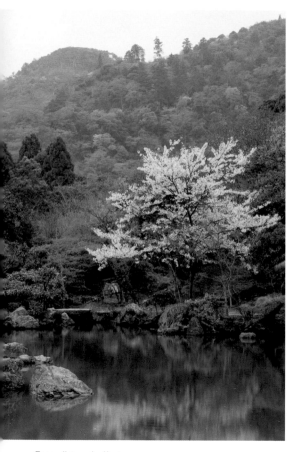

Tenryuji temple, Kyoto

"As you lay out your garden,
always remember to keep
your overall plan in mind."

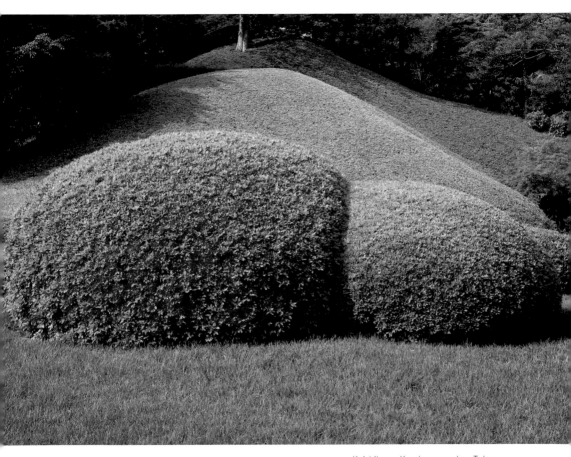

Koishikawa Korakuen garden, Tokyo

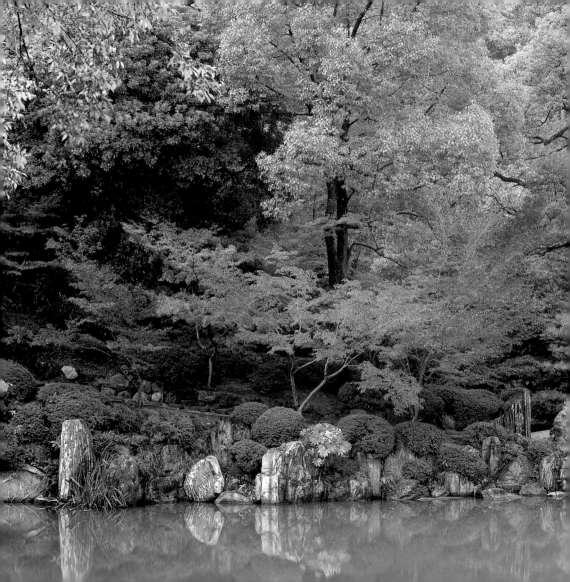

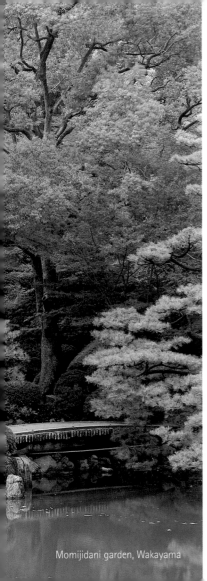

Momijidani garden, Wakayama

"When the Buddha preached he stood under a tree. When the Shinto gods come down from heaven they take up residence in trees. So is it not essential that human habitations should be surrounded by trees?"

"Apart from the special trees symbolizing the Four Cardinal Points you can plant trees wherever you like. However, it is worth knowing that people used to say that trees grown for their flowers should be planted on the east side of your garden, while trees grown for their foliage should be planted on the west side."

"Planting a tree
creates an earthly
paradise."

凡樹は人中天
上の荘厳也

"How to plant trees around your house
to ensure that the Four Cardinal Points
are effectively symbolized:

An ancient Chinese text states that a
stream flowing from the house towards
the east symbolizes the Blue Dragon.
If there is no stream, plant nine willow
trees instead.

A wide path to the west of the house
symbolizes the White Tiger. If there is no
such path, plant seven catalpas instead.

A pond to the south of the house
symbolizes the Red Bird. If there is no
pond, plant nine Judas trees instead.

A mound to the north of the house
symbolizes the Dark Warrior.
If there is no mound, plant three cypress
trees instead."

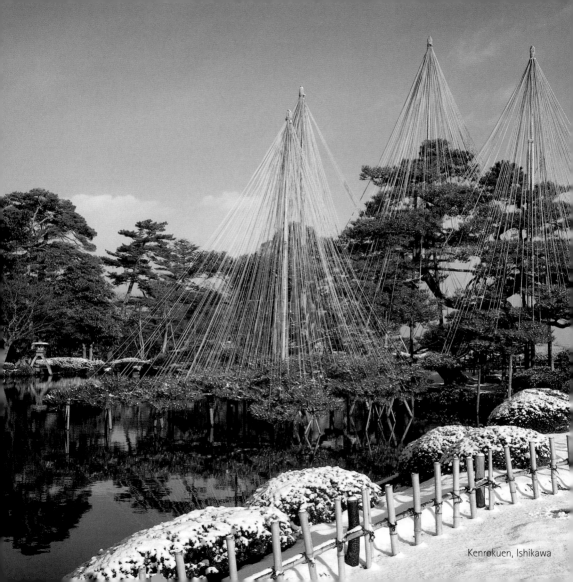

Kenrokuen, Ishikawa

"To capture the mood
of a mountain village or
some other attractive
country spot, build a tall
mound of earth near your
house and arrange a few
rocks so that they appear
to be flowing down from
the summit to the base."

山里

"When the Chinese
Emperor Qinshi Huangdi
burnt all the books and
buried the scholars alive,
he issued a special
decree exempting books
on the cultivation of
trees."

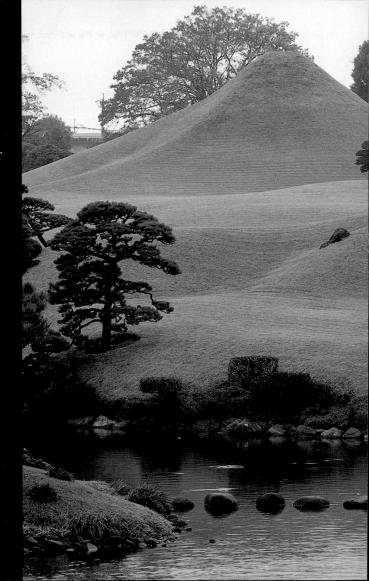

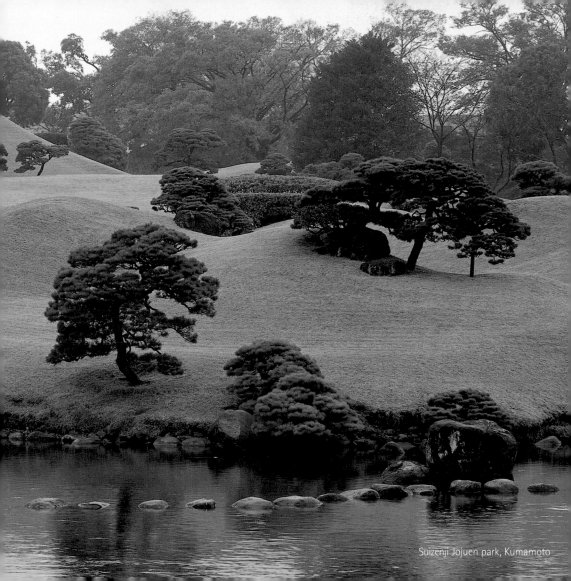

Suizenji Jojuen park, Kumamoto

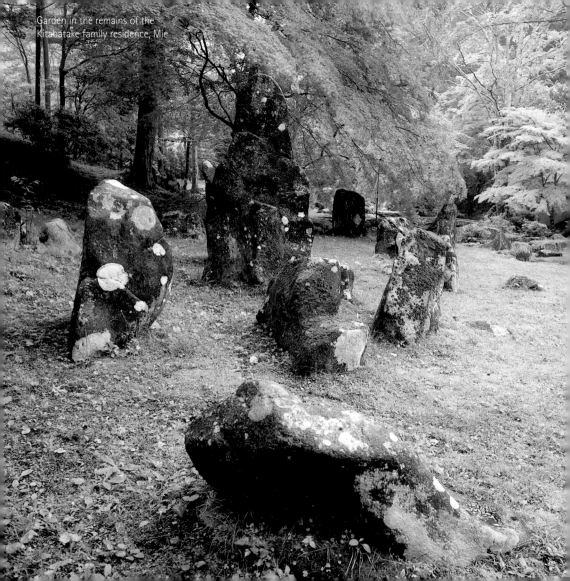
Garden in the remains of the
Kitabatake family residence, Mie

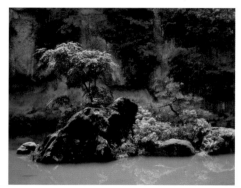

Natadera temple, Ishikawa

Chapter 6

Good and Evil

"Before you do anything else, decide where you want your stream to begin. According to the ancient Chinese texts, the water in a garden should normally flow from the east, first in a southerly direction and then towards the west...

It is best of all if the water starts in the east, passes underneath your house and then flows towards the southwest, taking water from the Blue Dragon in the east and flushing all evil influences away towards the White Tiger in the west. A household where this rule is observed will be free of epidemics and diseases of the skin, and its occupants will live long and peaceful lives... But if the stream has to start from the north it should turn east before flowing on towards the southwest."

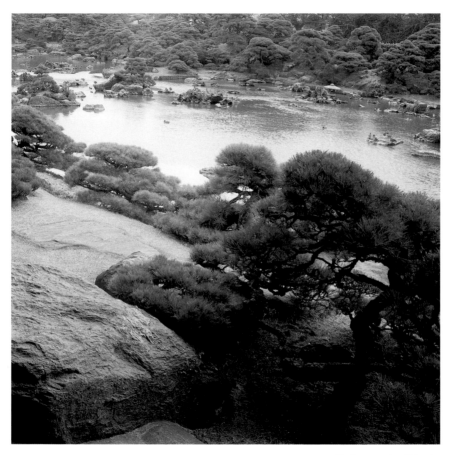

Shotoen garden, Fukuoka

身心安寿命長遠

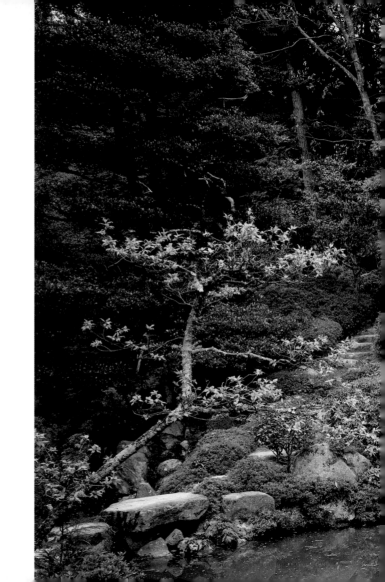

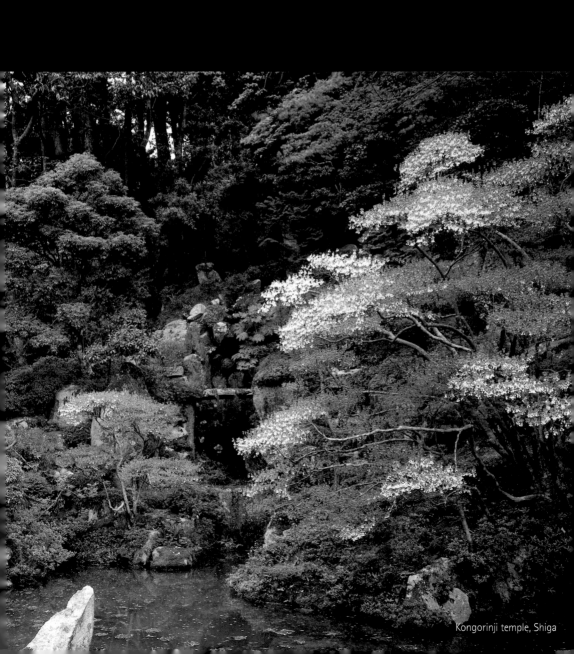

Kongorinji temple, Shiga

"I have come across several cases where stones gathered from mountains and rivers have turned back into evil spirits and brought bad luck... There is no such problem with stones gathered some distance away from mountains and rivers."

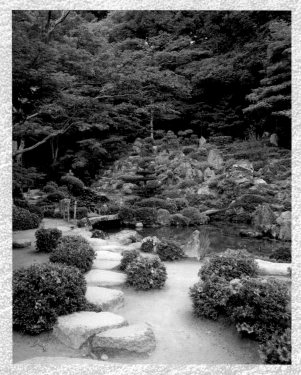

Saimyoji temple, Shiga

"You should never place stones more than five feet high in the north-northeast corner of your garden. This is the way that demons get in!"

"Do not set up a white stone that is larger than the others on the east side of your house. If you do, someone will commit a crime against you."

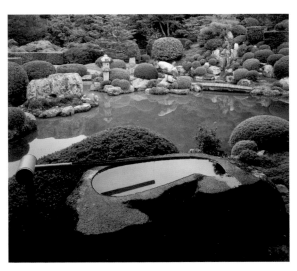

Jojuin shrine, Kiyomizudera temple, Kyoto

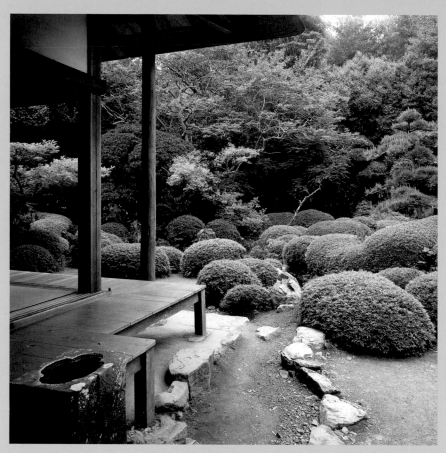

Saiokuji temple, Shizuoka

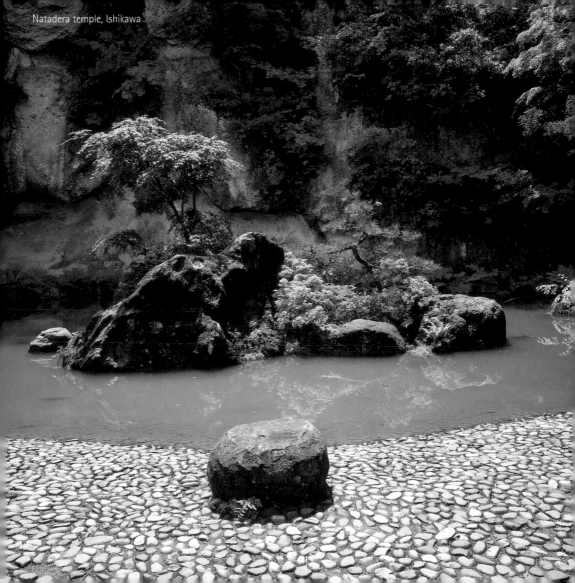
Natadera temple, Ishikawa

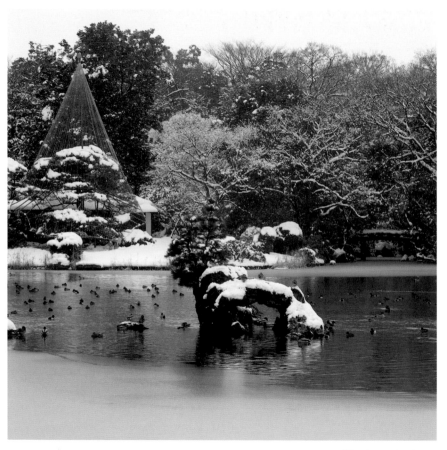

Rikugien garden, Tokyo

弘法大師高野山に至りて

"The great priest Kukai, the founder of the Shingon sect of Buddhism, went in search of the finest scenery in Japan and visited Mount Koya, where he met the guardian spirit of the place disguised as an old man. When Kukai asked him if there was anywhere on the mountain that might make a suitable site for a temple, the old man replied 'Within this domain of mine there is a place where purple clouds hang in the sky by day, where the five-needled pine emanates an auspicious glow by night and where all the waters flow towards the east. Such a place would be perfect even for a mighty castle.'

This might seem to contradict the teaching that water should flow towards the west, but in this case the eastward flow of the water symbolized the eastward spread of the Buddha's teaching. One need not follow this example when deciding how to lay out a house and its garden."

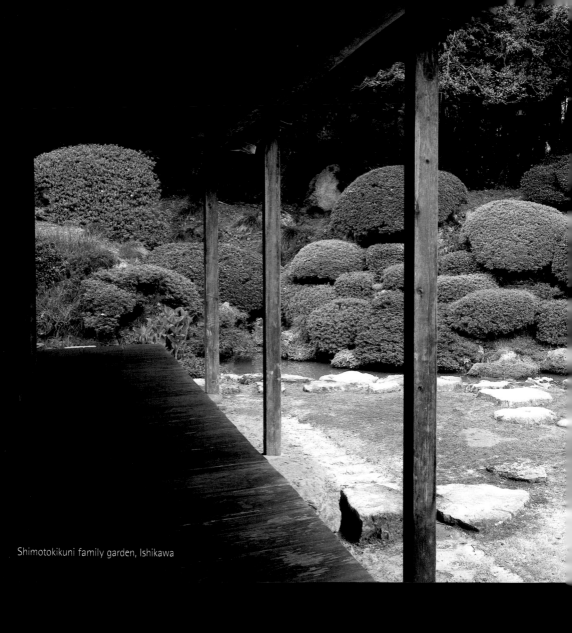

Shimotokikuni family garden, Ishikawa

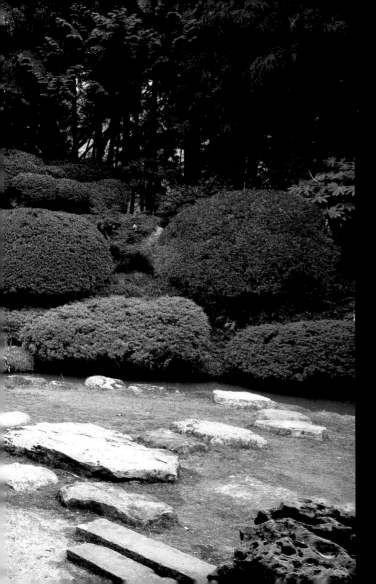

"Flat stones should never be set so that they point towards the northwest. If you break this rule, you will never grow rich."

"I have found that stones inhabited by vengeful spirits always land the right way up if they fall from a height. Such stones should not be used. Throw them away!"

"Some Chinese texts claim that the waters in a garden should flow from north to south. Since the north symbolizes water and the south symbolizes fire, maybe this saying should be taken to mean that if you make the water flow from north to south you will bring yin from the north and harmonize it with yang in the south."

"According to the ancient Chinese texts, the inner side of the curve of a stream symbolizes the belly of a dragon. It is auspicious if your house is located within the curve, but unlucky if it is located on the outside of the curve."

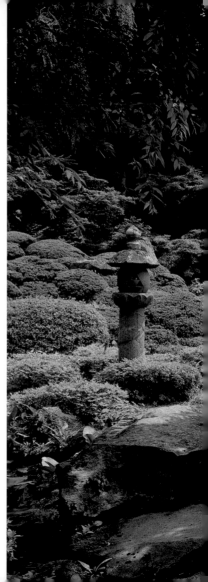

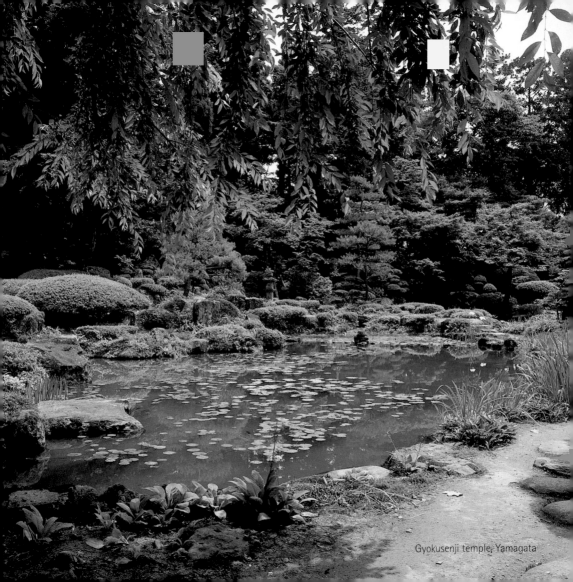

Gyokusenji temple, Yamagata

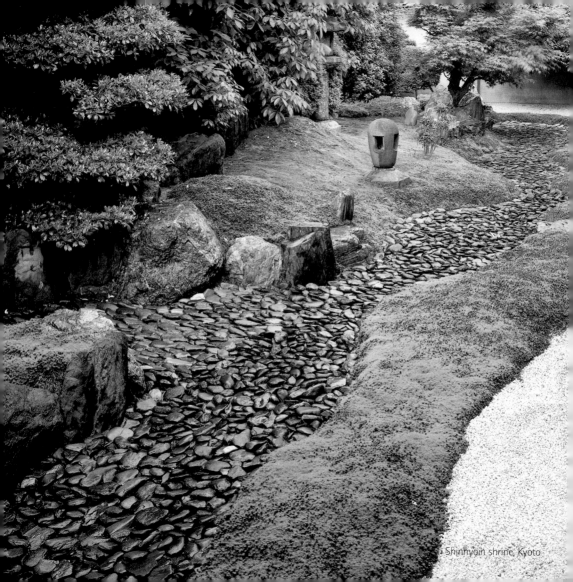

Shinnyoin shrine, Kyoto

石を立る事

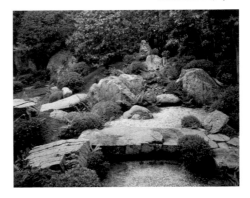

Taizoin shrine, Kyoto

Chapter 7

Stones

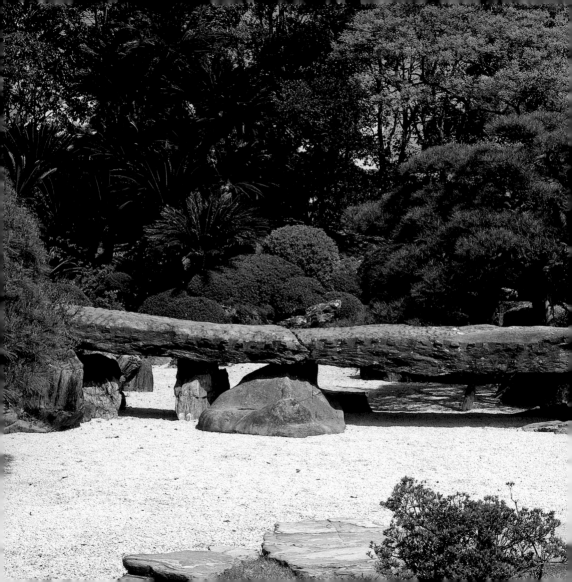

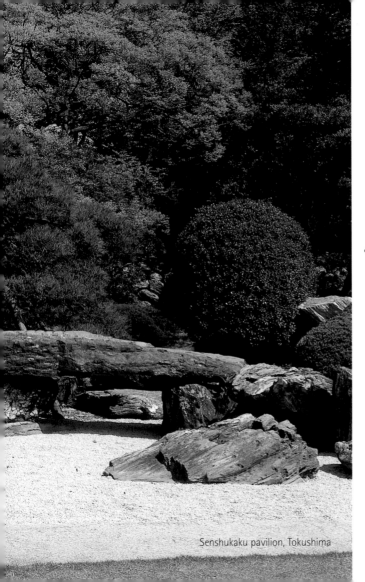

Senshukaku pavilion, Tokushima

"There should always be more horizontal than vertical stones."

"When you start work on your garden, have a selection of different-sized stones delivered and laid out on the ground so that you can see the tops of the standing stones and the upper surfaces of the lying stones. Then it will be easy for you to match and compare them, selecting stones one at a time as your design takes shape."

"Stones can be arranged around some garden feature, for example the bottom of a hill, the foot of a tree, or a pillar of your house."

Nagoya castle, Aichi

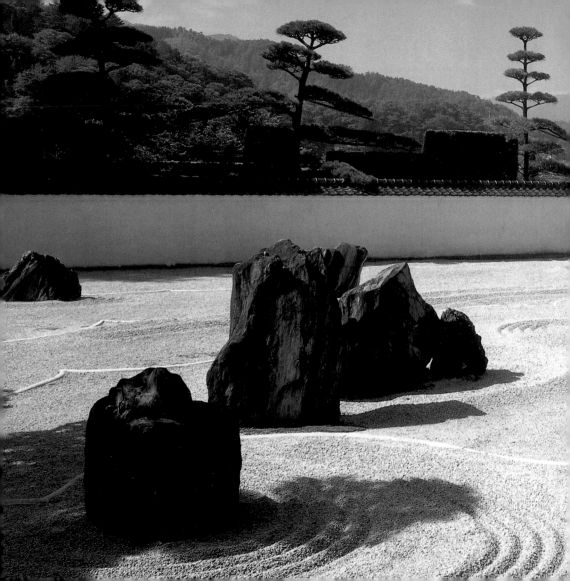

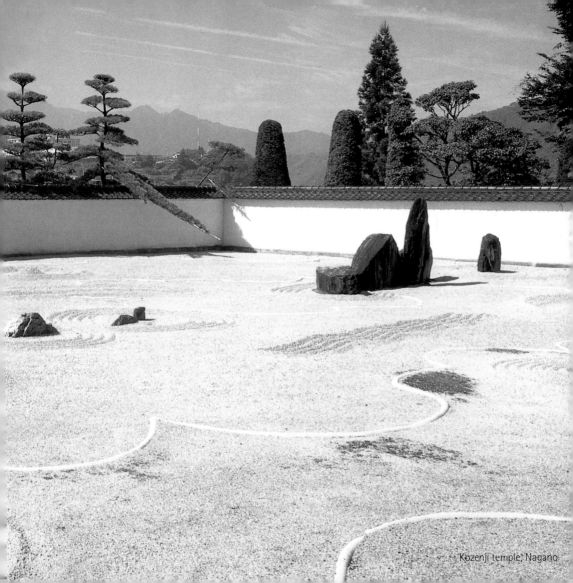
Kozenji temple, Nagano

宋人云

A Chinese commentator remarked: *"Stones that are found lying on a steep hillside or at the valley bottom sometimes come to rest the wrong way up after they have crumbled away from the tops of mountains or the sides of rivers. As the years go by they will change color and moss will grow on them. This process is quite natural, so when you use such stones in your garden you should not hesitate to place them as you found them, even though they were originally in a different position."*

Seishuraigoji temple, Shiga

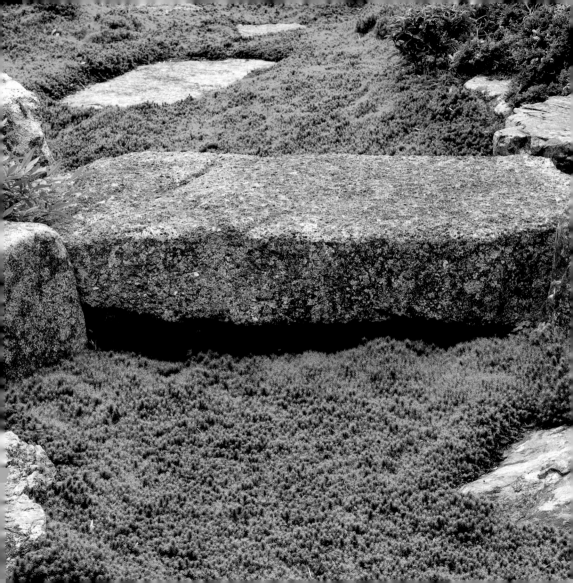

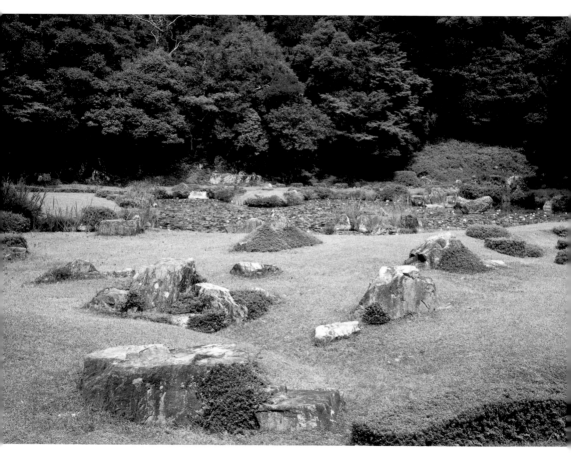

Joeiji temple, Yamaguchi

"Stones at the bottom of a hill where it meets the plain should look like dogs crouching on the ground, pigs running around, or a calf playing near its mother."

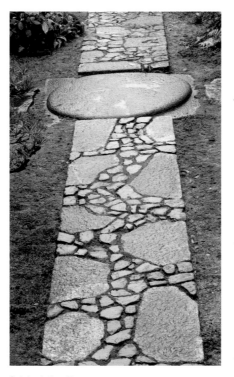

Saioin shrine, Kyoto

"If there are 'running away' stones there must be 'chasing' stones.

If there are 'leaning' stones there must be 'supporting' stones.

If there are 'assertive' stones there must be 'yielding' stones.

If there are 'upward-looking' stones there must be 'downward-looking' stones.

If there are 'vertical' stones there must be 'horizontal' stones."

石の乞んに従ひて立るなり

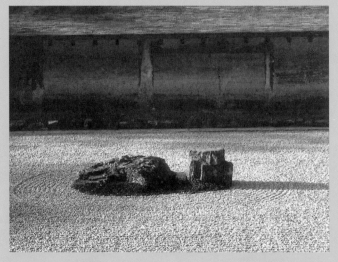

Ryoanji temple, Kyoto

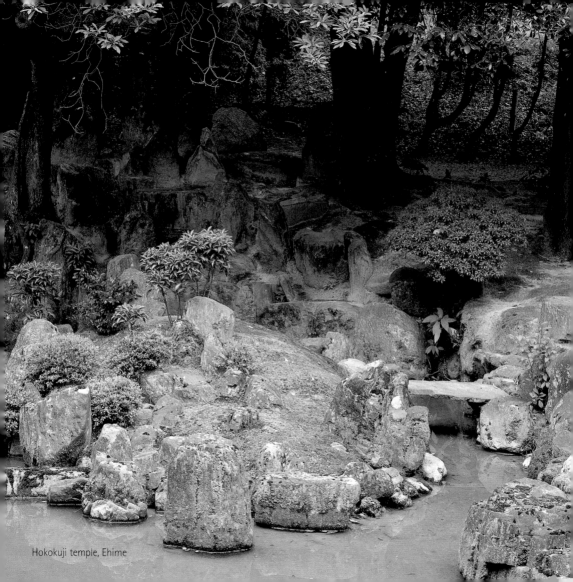

Hokokuji temple, Ehime

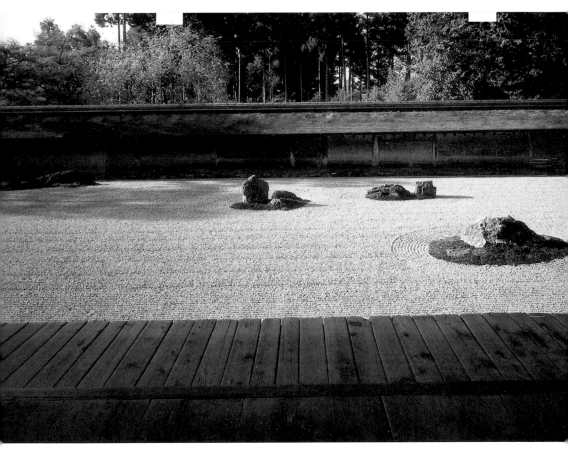

Ryoanji temple, Kyoto

枯山水

"When you build a *karesansui* (dry landscape) garden, you should first model the whole site to look like the base of a mountain or a hillside field, then arrange the stones so that they fit in with your overall design."

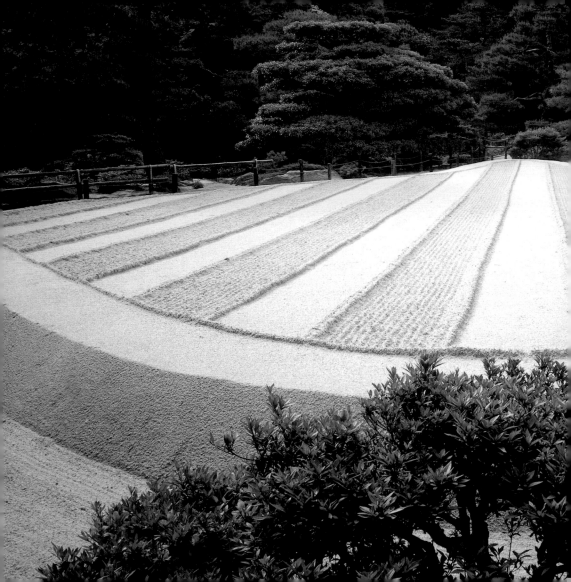

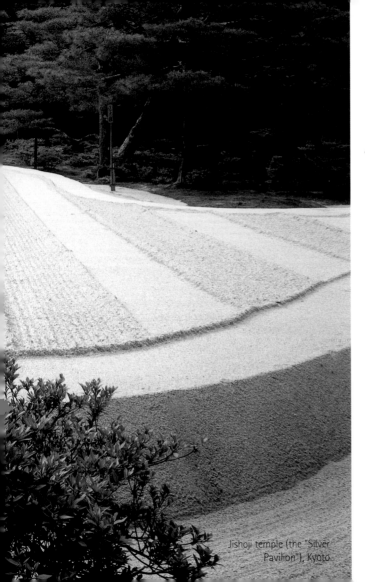

Jishoji temple (the "Silver Pavilion"), Kyoto.

"Gardens can be built in places where there are no ponds or streams. Such gardens are referred to as *karesansui*."

"Try not to place tall stones on either side of waterfalls, in front of islands, or at the foot of mounds."

臥る石に立てる石
のなきは苦みなし

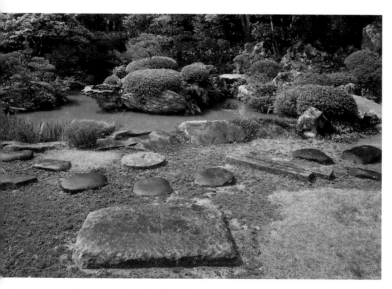

Fukada family garden, Tottori

"It is not a problem if a lying stone does not have a standing stone next to it, but a standing stone must have accompanying stones to left and right, and the foremost standing stone in an arrangement must have a lying stone next to it. It looks stupid when standing stones, without horizontal stones, are laid out in rows like the rivets on a helmet!"

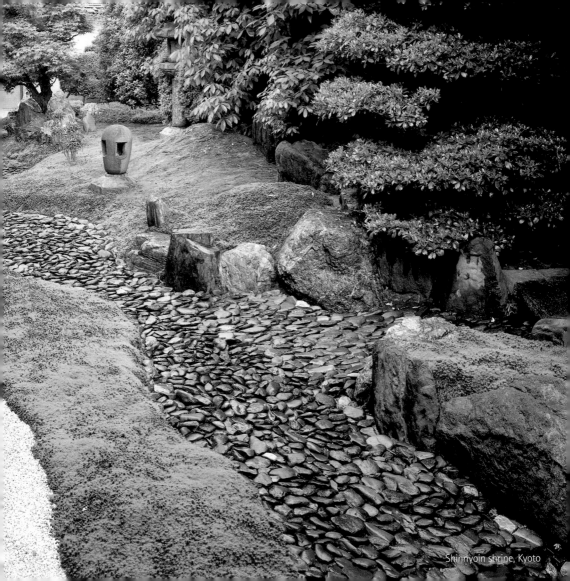
Shinnyoin shrine, Kyoto

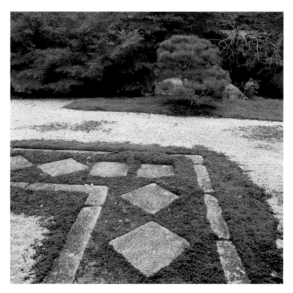

Tenjuan sub-temple, Kyoto

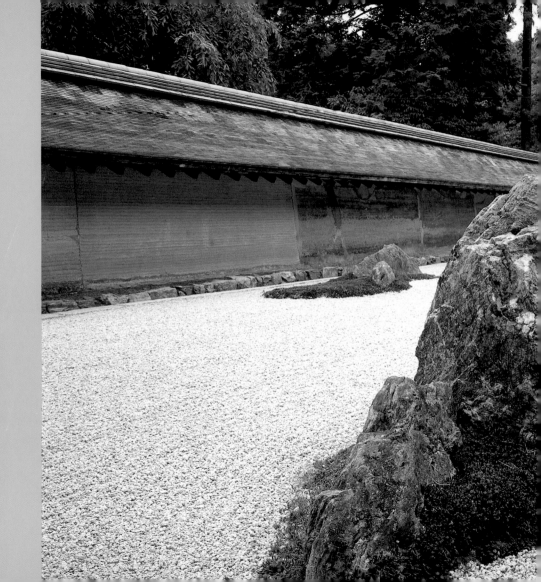

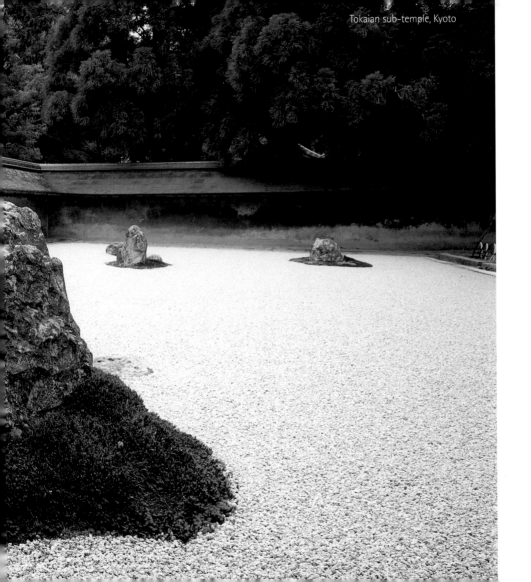

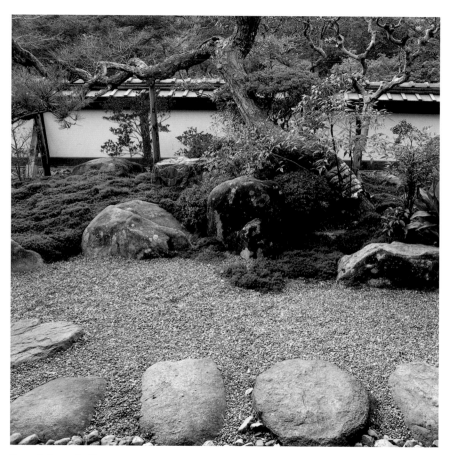

Shoryakuji temple, Nara

"Stones should be set securely in place with their bases deep in the ground. Even so a second stone can be leant against a securely placed stone in such a way that the first stone looks insecure, and vice versa. There is a secret teaching about this!"

"Make sure that all the stones, right down to the one at the front of the arrangement, are placed with their best sides showing. If a stone has an ugly-looking top you should place it so as to give prominence to its side. Even if this means it has to lean at a considerable angle, no one will notice."

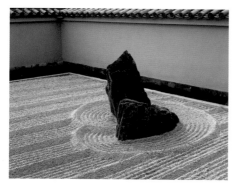

Daitokuji temple, Kyoto

"Create your foreground design by combining a suitably-shaped principal stone with two smaller stones to its left and right. The arrangement of the stones in the background should be dictated by the needs of the principal stone."

"Always begin by positioning a particularly well-shaped stone and let it dictate the arrangement of all the other stones."

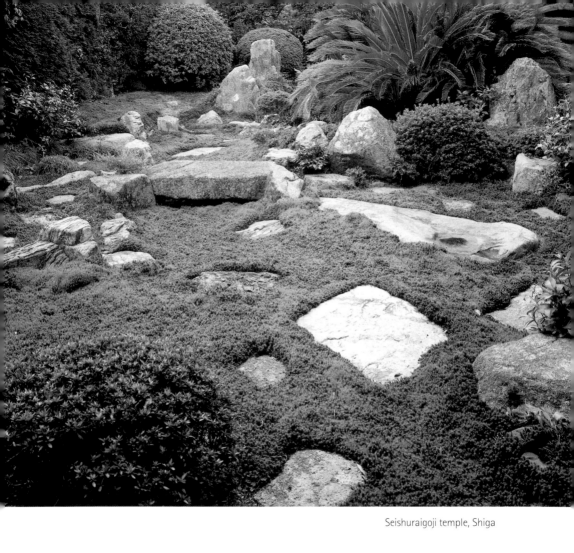

Seishuraigoji temple, Shiga

"Although I have managed to get hold of several treatises on gardening and learn the basic principles of garden design, I have come to realize that there are almost endless possibilities, including many that are far too profound for me."

予又その文書を伝へ得たり。
如此相営みて大旨を心得た
りと雖も、風情尽ることなく
して、心及ばざること多し。

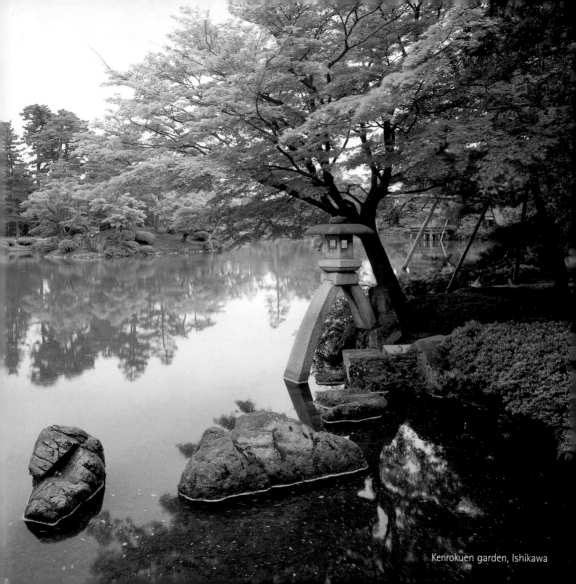

Kenrokuen garden, Ishikawa

The Tuttle Story
"Books to Span the East and West"

Most people are surprised to learn that the world's largest publisher of books on Asia had its humble beginnings in the tiny American state of Vermont. The company's founder, Charles Tuttle, came from a New England family steeped in publishing, and his first love was books—especially old and rare editions.

Tuttle's father was a noted antiquarian dealer in Rutland, Vermont. Young Charles honed his knowledge of the trade working in the family bookstore, and later in the rare books section of Columbia University Library. His passion for beautiful books—old and new—never wavered throughout his long career as a bookseller and publisher.

After graduating from Harvard, Tuttle enlisted in the military and in 1945 was sent to Tokyo to work on General Douglas MacArthur's staff. He was tasked with helping to revive the Japanese publishing industry, which had been utterly devastated by the war. When his tour of duty was completed, he left the military, married a talented and

beautiful singer, Reiko Chiba, and in 1948 began several successful business ventures.

To his astonishment, Tuttle discovered that postwar Tokyo was actually a book-lover's paradise. He befriended dealers in the Kanda district and began supplying rare Japanese editions to American libraries. He also imported American books to sell to the thousands of GIs stationed in Japan. By 1949, Tuttle's business was thriving, and he opened Tokyo's very first English-language bookstore in the Takashimaya Department Store in Ginza, to great success. Two years later, he began publishing books to fulfill the growing interest of foreigners in all things Asian.

Though a westerner, Tuttle was hugely instrumental in bringing a knowledge of Japan and Asia to a world hungry for information about the East. By the time of his death in 1993, he had published over 6,000 books on Asian culture, history and art—a legacy honored by Emperor Hirohito in 1983 with the "Order of the

Sacred Treasure," the highest honor Japan bestows upon non-Japanese.

The Tuttle company today maintains an active backlist of some 1,500 titles, many of which have been continuously in print since the 1950s and 1960s—a great testament to Charles Tuttle's skill as a publisher. More than 60 years after its founding, Tuttle Publishing is more active today than at any time in its history, still inspired by Charles Tuttle's core mission—to publish fine books to span the East and West and provide a greater understanding of each.